My dear Kevin,

Whenever you need a little escape ... Enter the world of Fairies!

love,
momma

Christmas, 2010.

"If you believe," he shouted to them, "clap your hands; don't let Tink die."

— J. M. Barrie

Peter and Wendy
(1911)

Faeries

and other Fantastical Folk

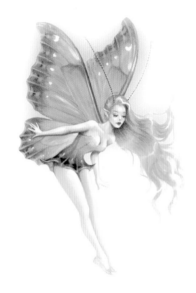

The Faery Paintings of
Maxine Gadd

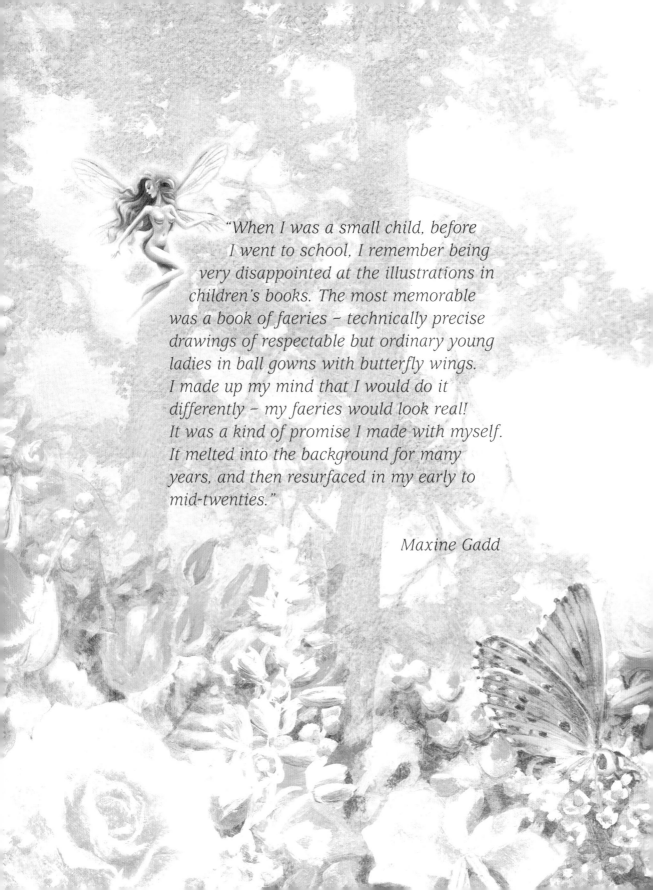

*"When I was a small child, before
I went to school, I remember being
very disappointed at the illustrations in
children's books. The most memorable
was a book of faeries – technically precise
drawings of respectable but ordinary young
ladies in ball gowns with butterfly wings.
I made up my mind that I would do it
differently – my faeries would look real!
It was a kind of promise I made with myself.
It melted into the background for many
years, and then resurfaced in my early to
mid-twenties."*

Maxine Gadd

Faeries

and other Fantastical Folk

The Faery Paintings of Maxine Gadd

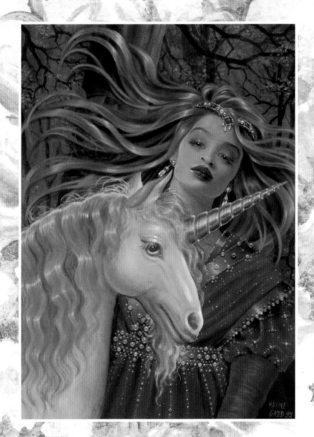

WITH A TEXT BY JOHN GRANT

AAPPL

Faeries and other Fantastical Folk
The Faery Paintings of Maxine Gadd

Published in Great Britain and USA by
AAPPL Artists' and Photographers' Press Ltd.
Church Farm House, Wisley, Surrey, GU23 6QL, UK
info@aappl.com www.aappl.com

Sales and Distribution
UK and export: Turnaround Publisher Services Ltd
sales@turnaround-uk.com
USA and Canada: Sterling Publishing Inc., sales@sterlingpub.com
Australia & NZ: Peribo michael.coffey@peribo.com.au
South Africa: Trinity Books trinity@iafrica.com
First published 2005
Copyright © AAPPL Artists' and Photographers' Press Ltd 2005
Pictures © Maxine Gadd 2005

This first reprint © AAPPL 2006

A catalogue record for this book is available from the British Library.

ISBN 1-904332-24-2

Design (contents and cover): Malcolm Couch
mal.couch@blueyonder.co.uk

Printed in China by: Imago Publishing
info@imago.co.uk

PRECEDING PAGE:

Nexus

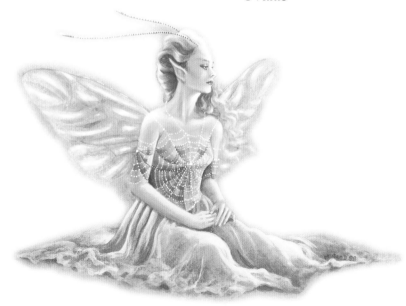

Contents

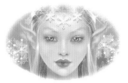
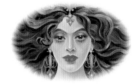
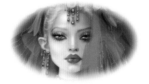
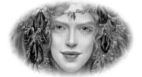
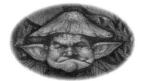

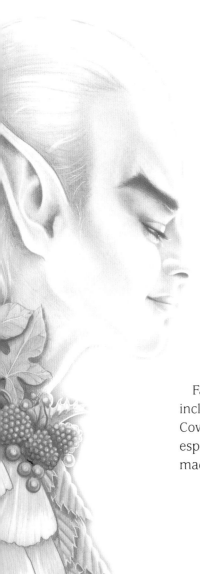

A Journey into Faerie

To most of us, the faeries reveal themselves in mysterious ways. A glancing light that we see out of the corner of our eye, the subtle movement of a leaf or twig that stops by the time we turn to look . . . We've sensed the presence of the faeries, but we haven't been able to see one.

A few people over the ages – a very few people – have been luckier. To them the faeries have opened the wonders of their world to full view: the magical colours, the enchantments, the strange and marvellous creatures who share Faeryland.

And, of those lucky few, a mere handful have been fortunate enough to be gifted artists, able to bring to us their glimpses of the realm that remains otherwise forever unseen. Among these artists is Maxine Gadd.

She comes from a distinguished artistic lineage. Perhaps the most famous of those visionary artists who have gone before her has been Arthur Rackham, among the greatest of the Victorian illustrators and a prolific painter of Faeryland. Approximate contemporaries of Rackham's included John Anster Fitzgerald, Richard Doyle, Frank Cadogan Cowper, John William Waterhouse, Joseph Noel Paton and most especially Richard Dadd, the artist who, confined to the madhouse for most of his adult life, obsessively produced there

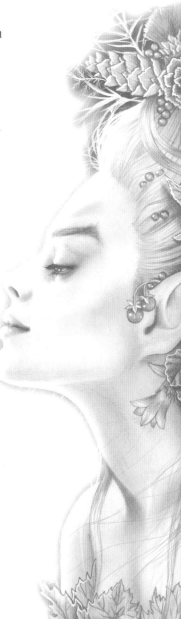

scenes of Faerie that, once viewed, can never be forgotten.

After the Victorian era, for the next few decades the faeries seemed, with a few exceptions, to choose to hide themselves from mortal eyes once more – even from the eyes of visionary artists. But then, toward the end of the last century, they relented, and there was a tremendous renaissance of faery art, a new outpouring of visions. Among the foremost of the painters to be thus favoured was the one whose superb, entrancing and sometimes even eerie pictures fill almost to overflowing the book you now hold.

What this book's pages really hold, of course, is something more than pictures: it is your own journey to Faerie. Gaze deeply into each of the scenes you see here and you will begin to hear the creak of the bough, the rustle of the leaves, the flurry of small wings, and the chatter of voices in a tongue unknown to mortals . . .

And beware, even as you wonder at the otherworldly strangeness and beguilement you find yourself amidst. Some of the folk who've ventured into Faerie have not been seen by mortal eyes again.

"Art in any form is a type of magic."

– Maxine Gadd

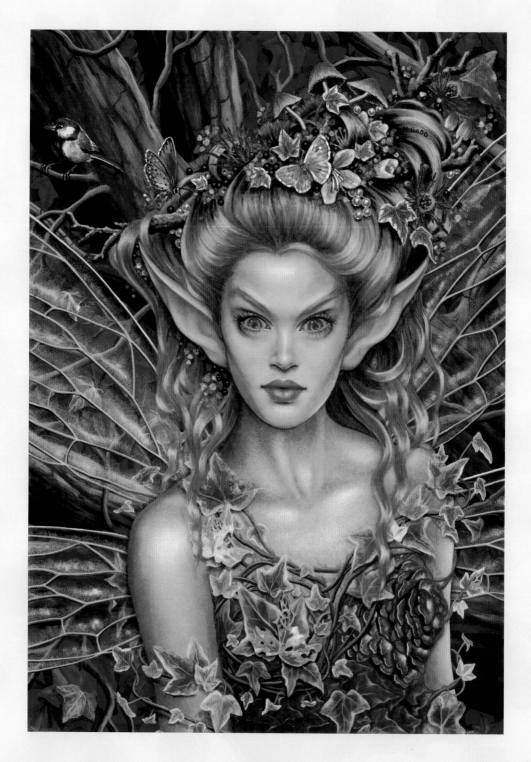

Chrysella

Faeries, Faeries, Faeries

Where the bee sucks, there suck I
In a cowslip's bell I lie;
There I couch when owls do cry.
On the bat's back I do fly . . .

– William Shakespeare,
The Tempest (c.1611)

Faeries take many forms, each more magical than the last. From mischievous imps and sprites to fluttering pixies to malicious goblins to sinisterly graceful elves and Sidhe, they coexist in the land called Faerie, which is forever just around the corner from our perceptions. They have their royal courts, where monarchs like Oberon and Titania reign in sylvan pomp, while courtiers scurry around them on incomprehensible errands. Elsewhere in the realms of Faerie, others celebrate mysterious rituals or merely display themselves to the Sun so that the Sun may admire their beauty.

The gates to Faerie are open before you, and you have been invited to pass through them. Dare you venture within?

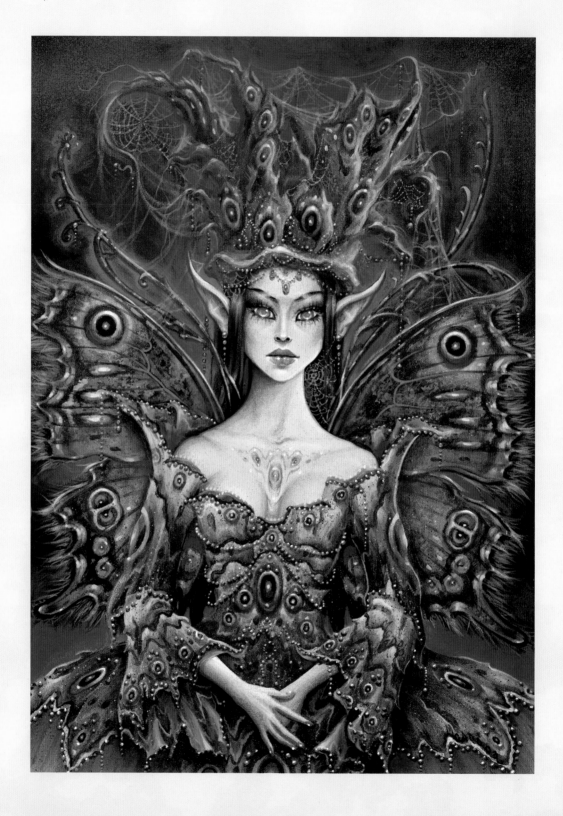

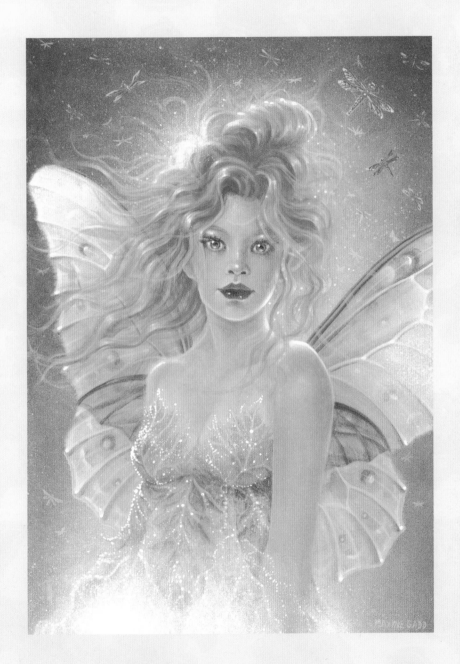

Mirrabelle

LEFT:

Arryan

"Children are so honest.
To me there is no greater
compliment than when a
child likes my art. It brings
tears to my eyes."

Maxine Gadd

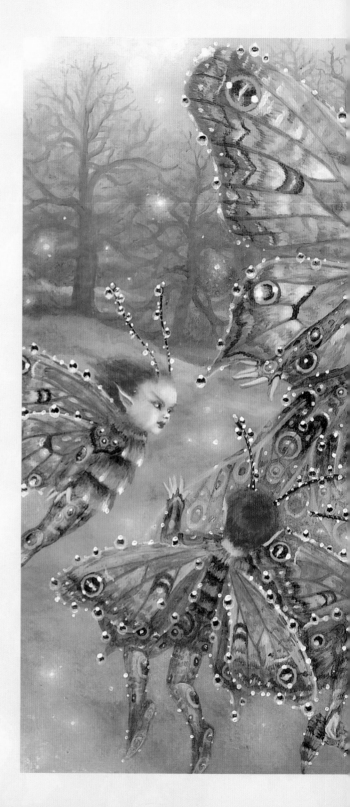

The Flying Faeries

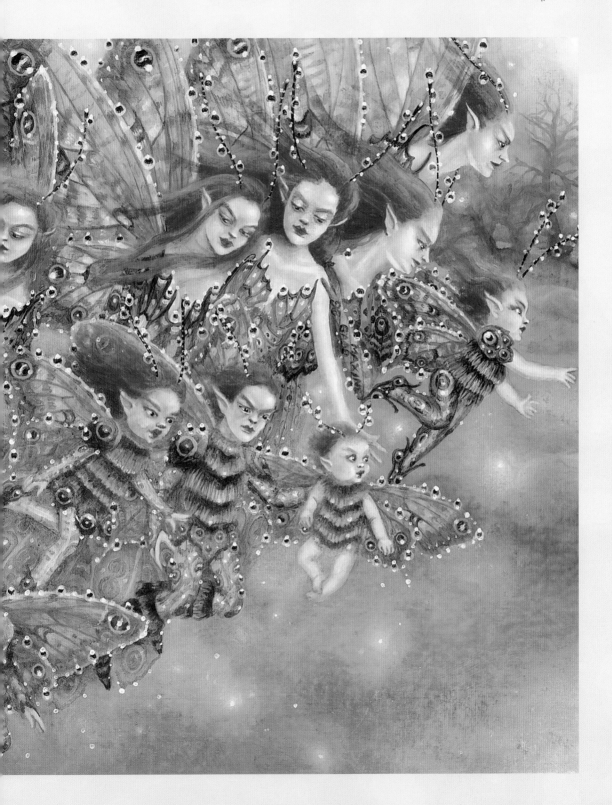

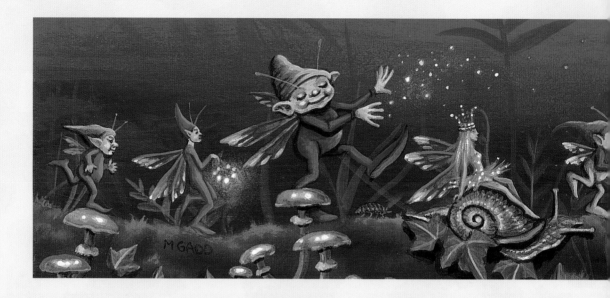

Faery Procession

*"For me the faery realm is a kind of utopia.
I think the faeries have their priorities in the right order.
For one thing, they live closely with the
elements. Love and beauty are all-important.
They never hold back on their emotions,
and they love to play games and tricks on each other
as well as mortals."*

Maxine Gadd

RIGHT:

Butterfly Fairy

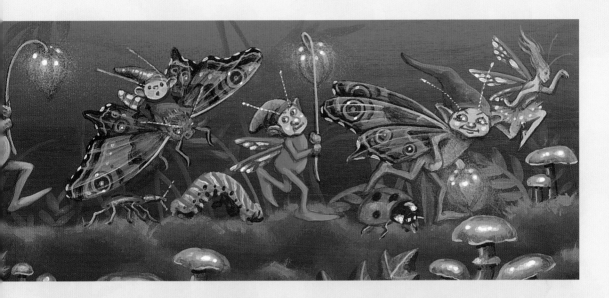

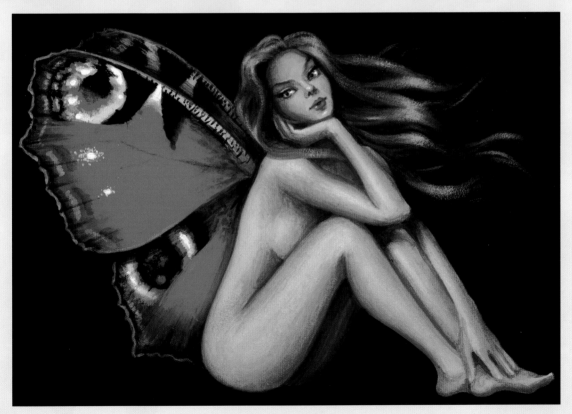

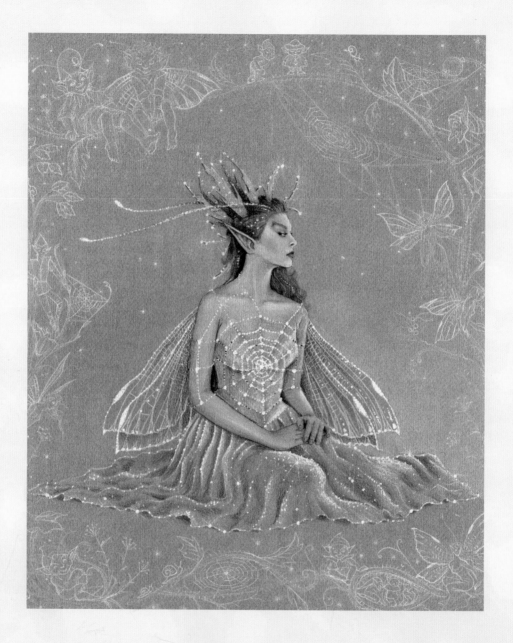

Blue Faery

RIGHT:

Dusk

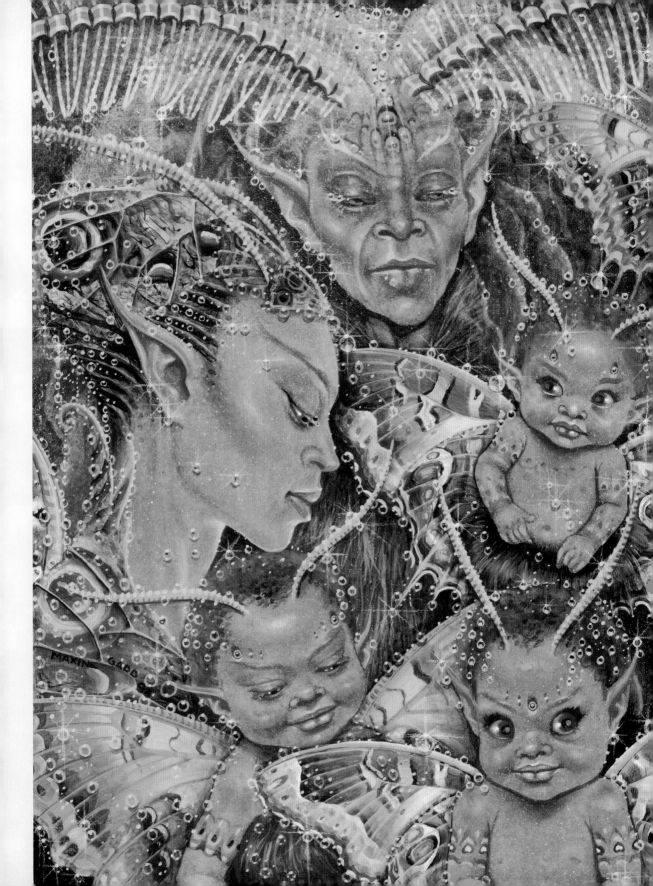

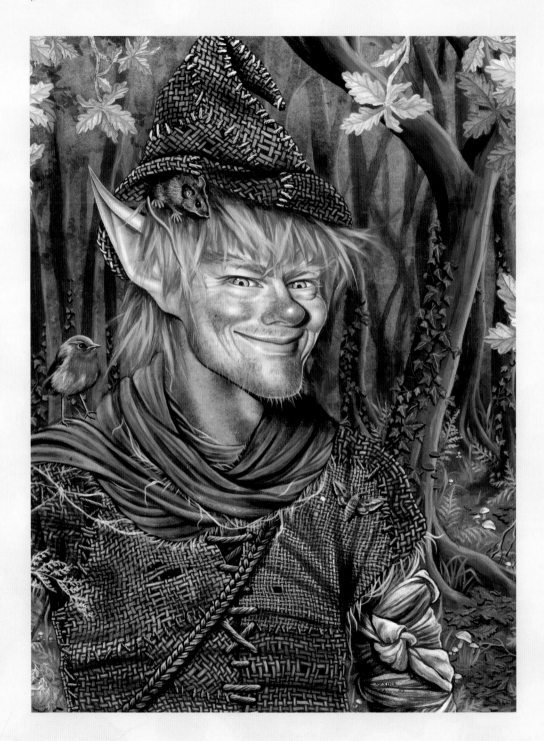

Wisp

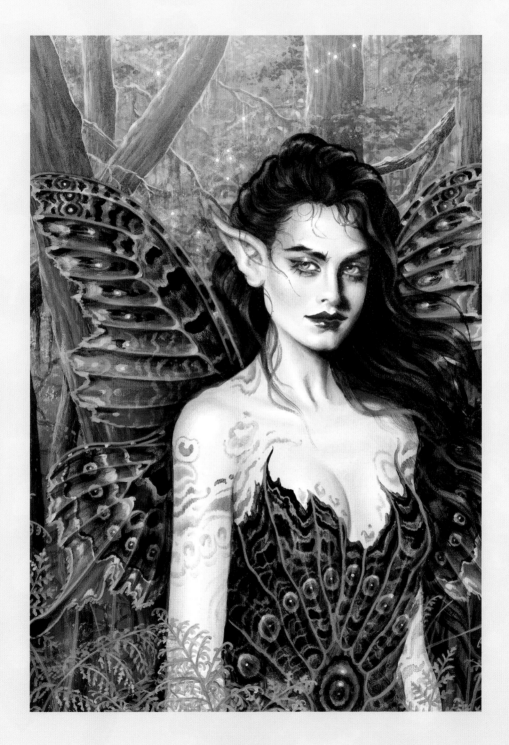

Darkle

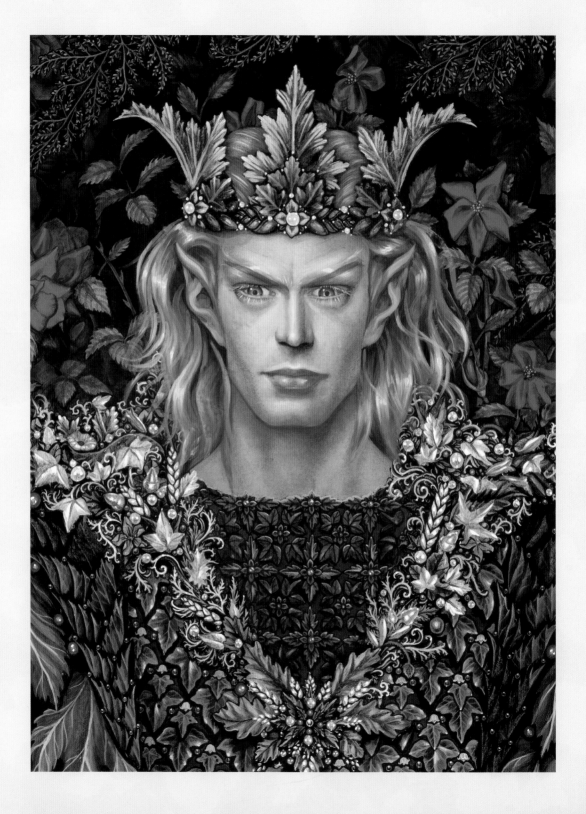

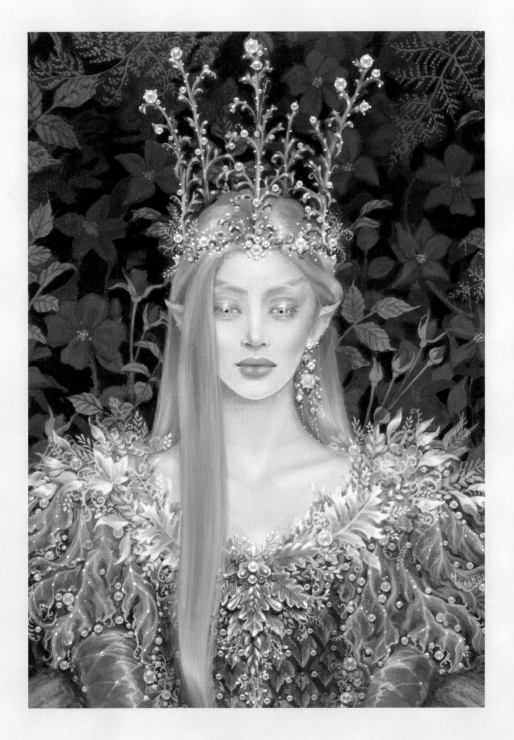

The Elf King and the Elf Queen

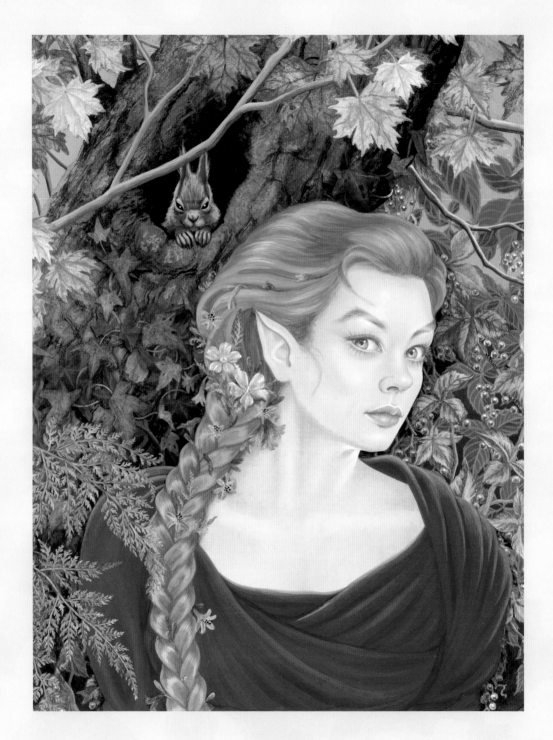

Elfine

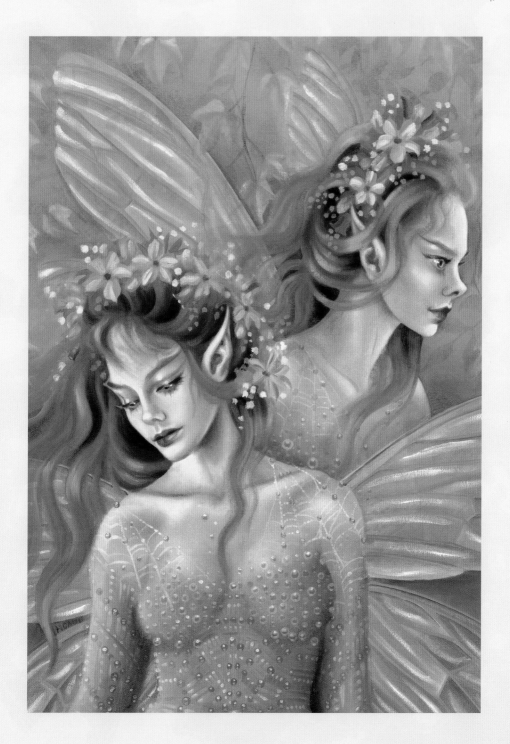

Spring

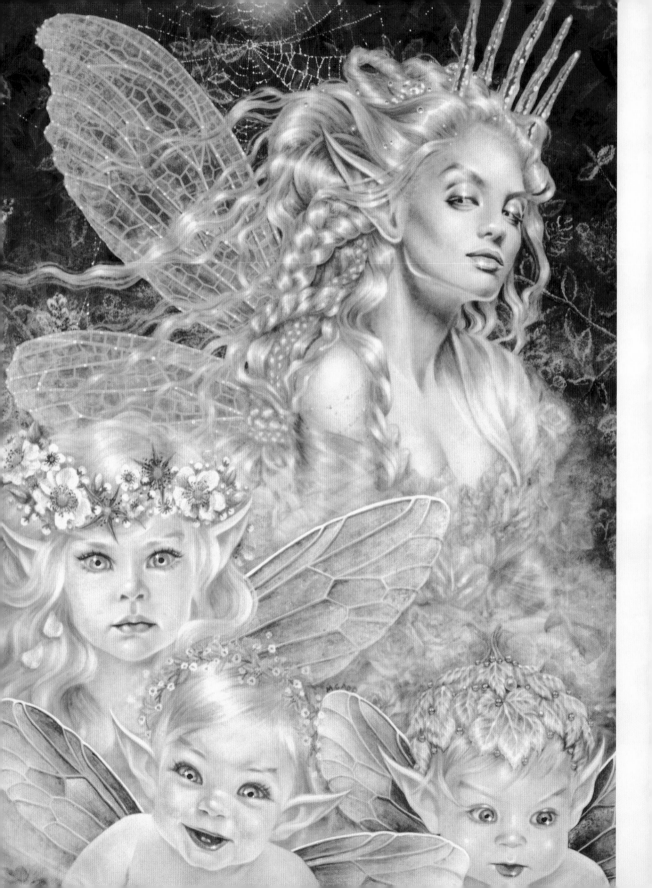

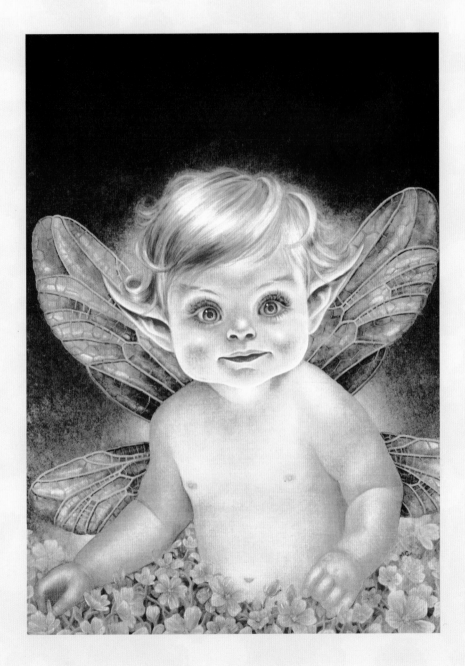

Baby Chrysella

LEFT:

Frost

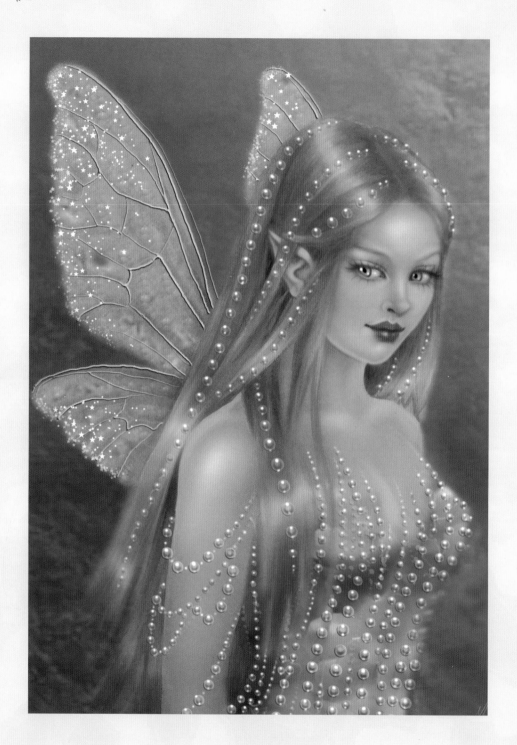

Rainbow Sprite

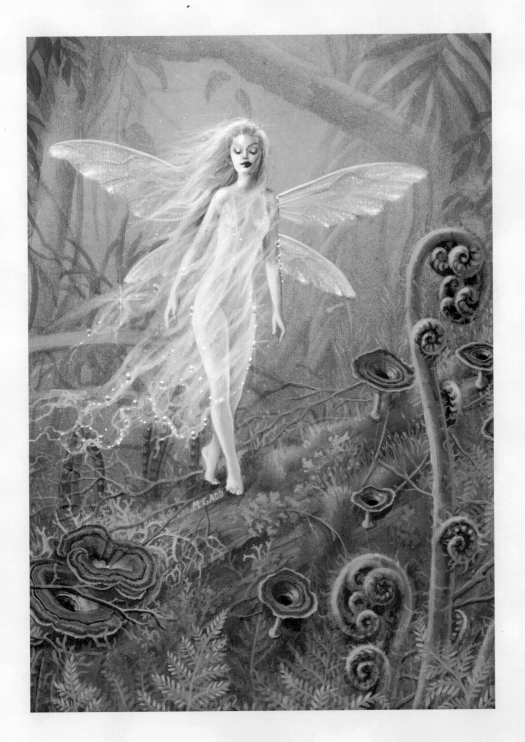

Forest Sprite

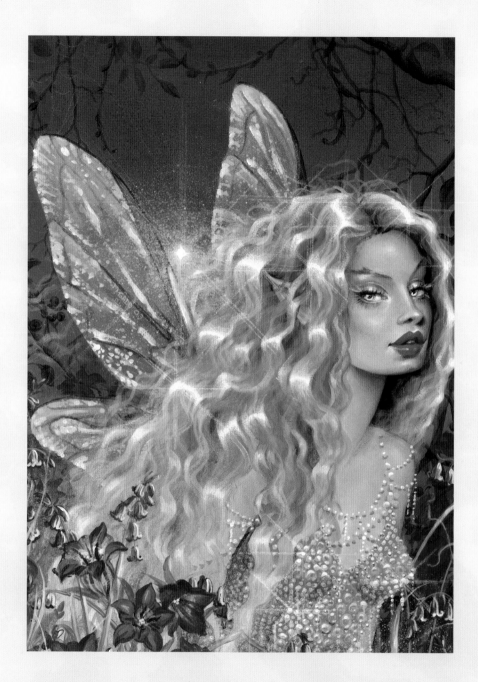

Faya

RIGHT:

Snowflake

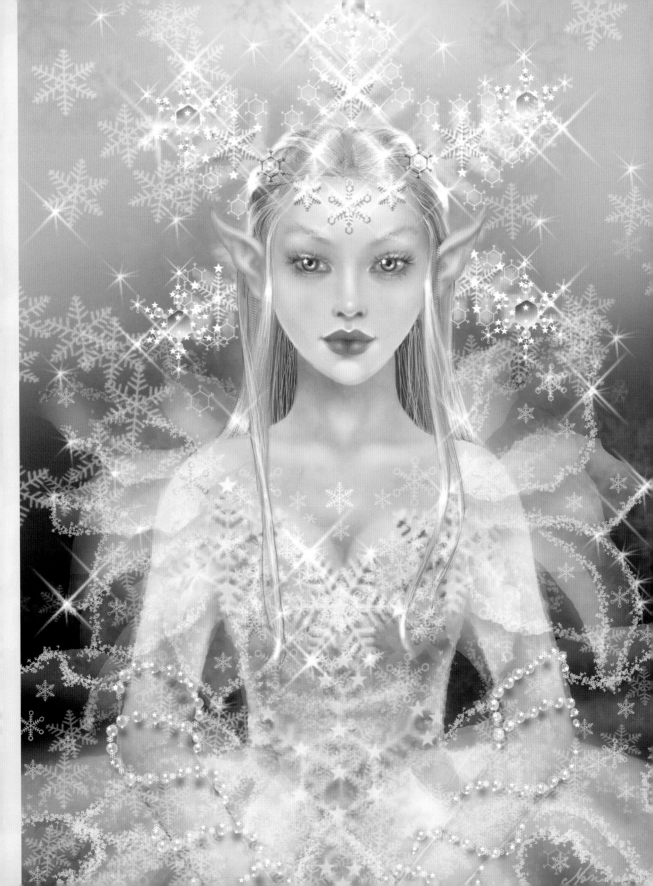

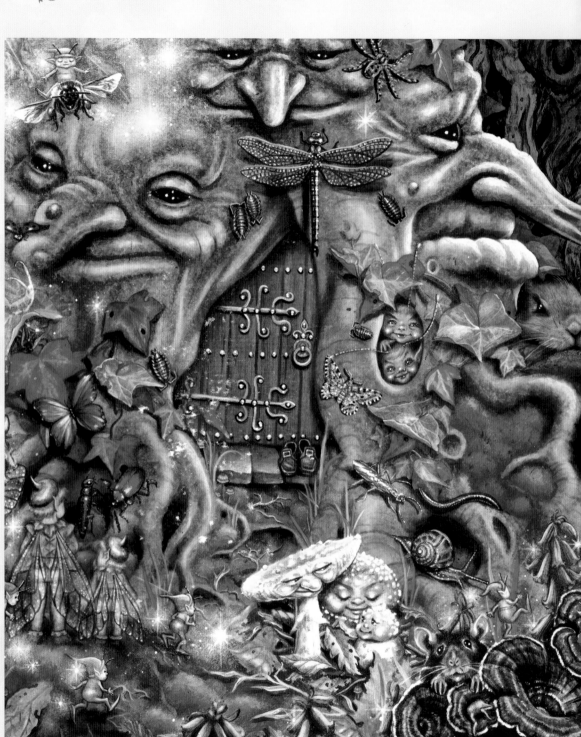

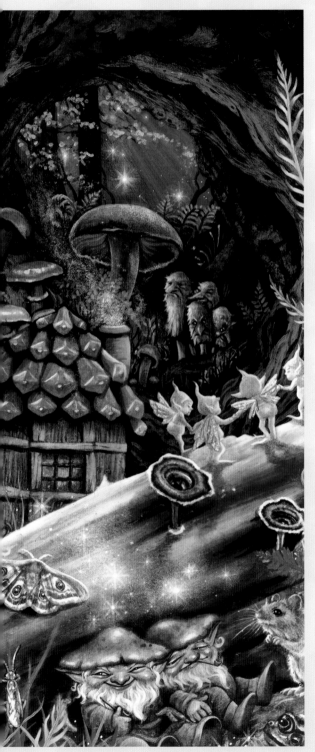

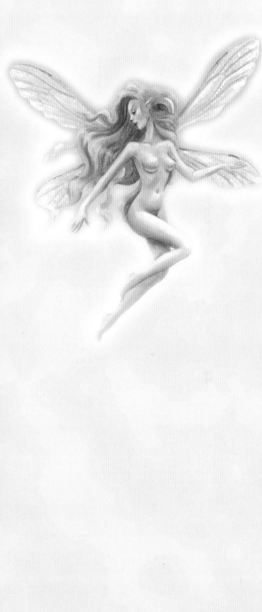

Forest Floor

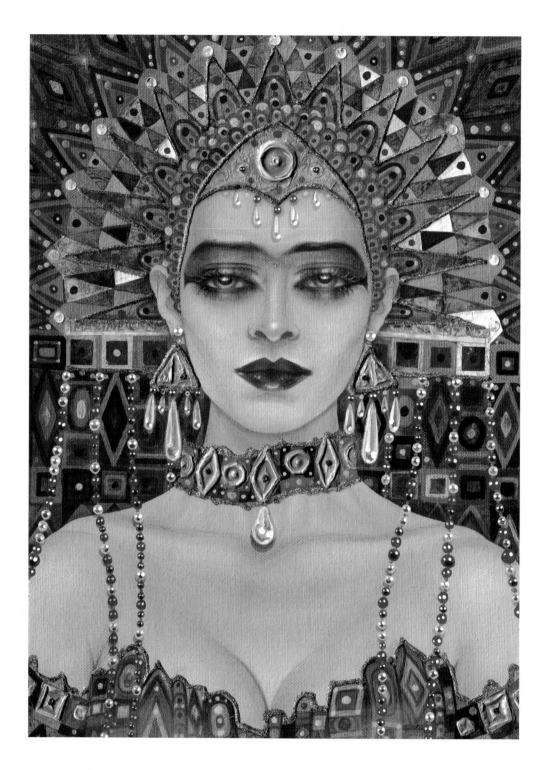

Mosaic

Faery Goddesses

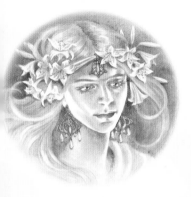

Faeries are enchanted creatures who can perform all sorts of magics that are far outwith the scope of mortal comprehension. We can only gaze in awe and wonder at the marvels they daily conjure. Imagine, then, how much farther beyond the human dream are the goddesses who rule over the faeries!

Greatest of all the faery goddesses is the Earth Mother herself, who gave birth to everything there is and to all of us – humans and faeries alike. But the Earth Mother is largely content to sleep these times, and in the shadows outside her attention there are stages upon which her lesser goddesses can play.

Even when within Faeryland, you may never see one of these beings. Who knows whether you should be grateful or crestfallen that this is so . . .

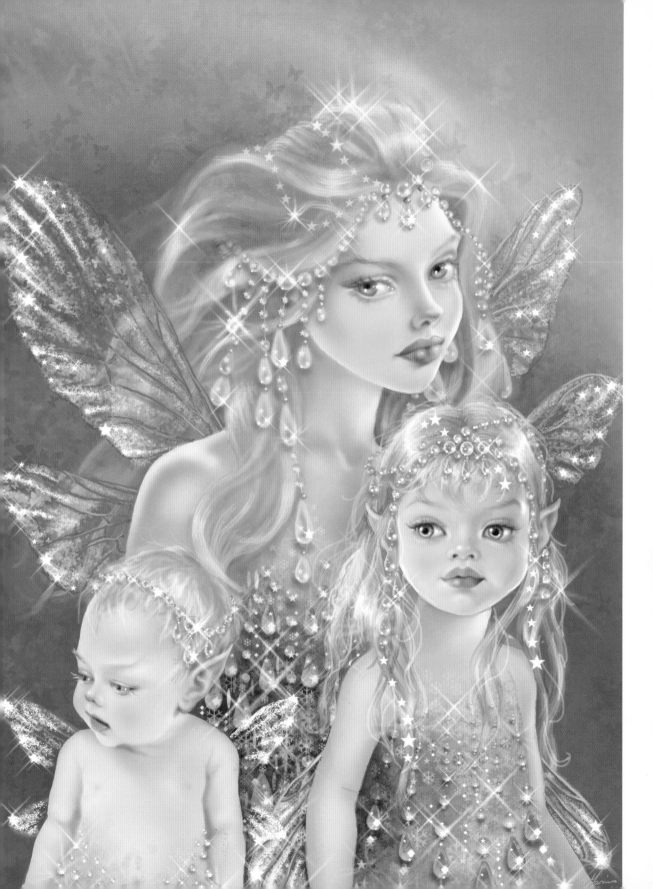

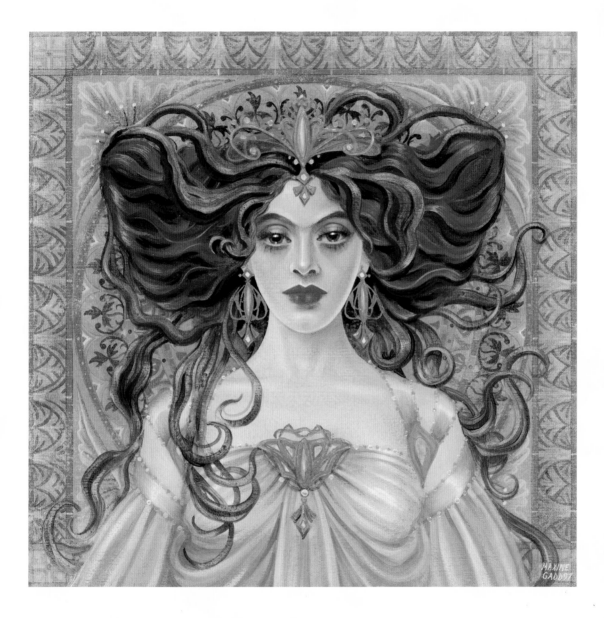

Elspeth

LEFT:

Rainlight

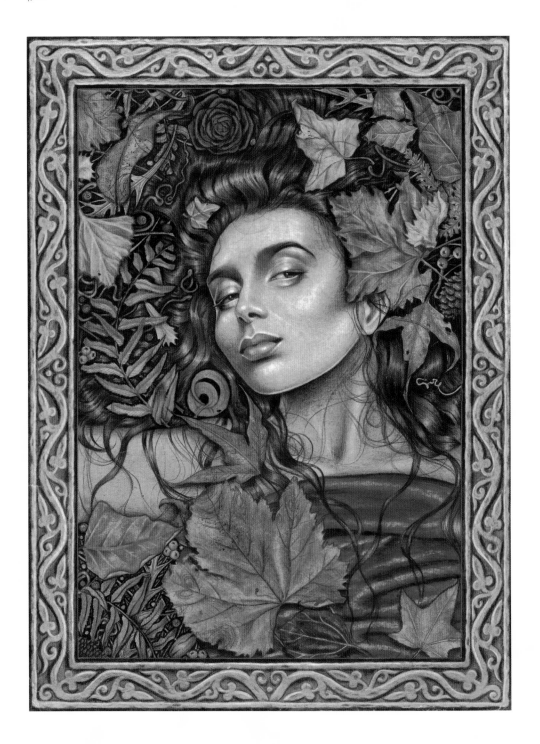

Forest Bed

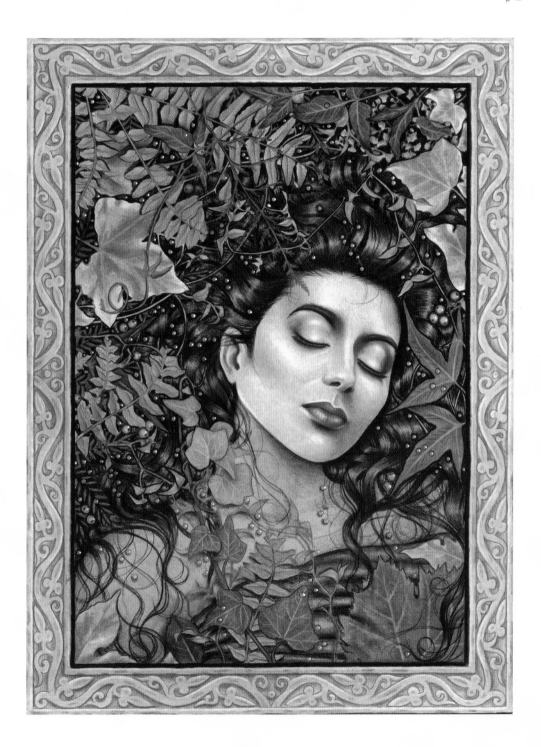

Dreaming

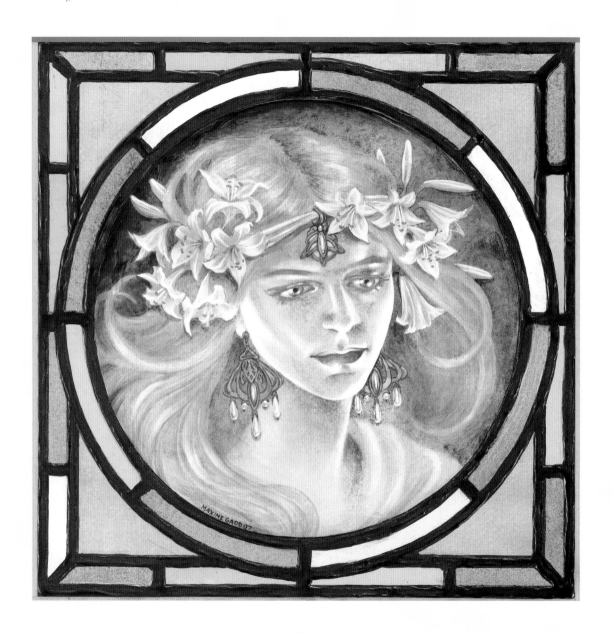

Glass

RIGHT:
Dewberry

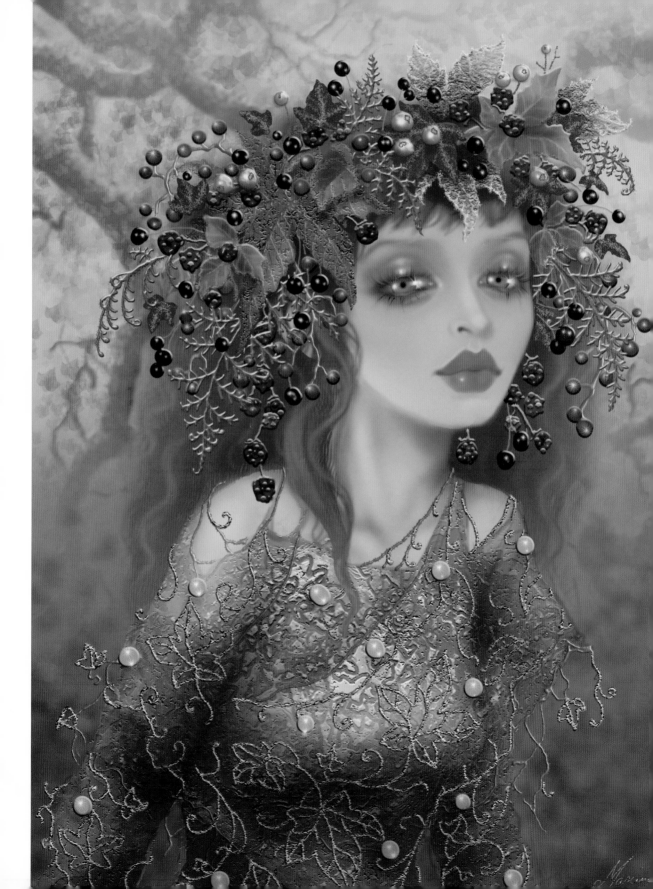

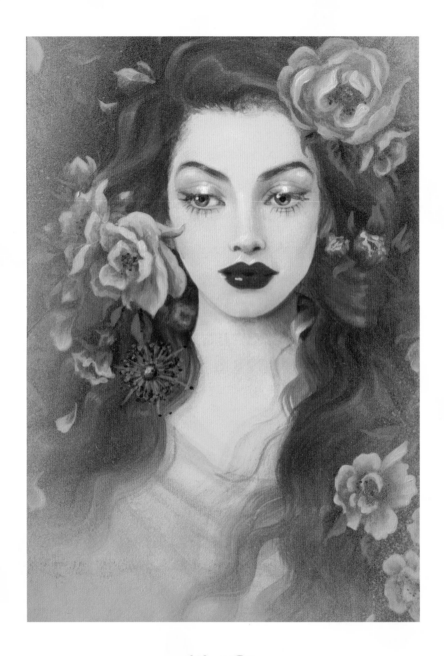

Musk Rose

RIGHT:

Alburnus

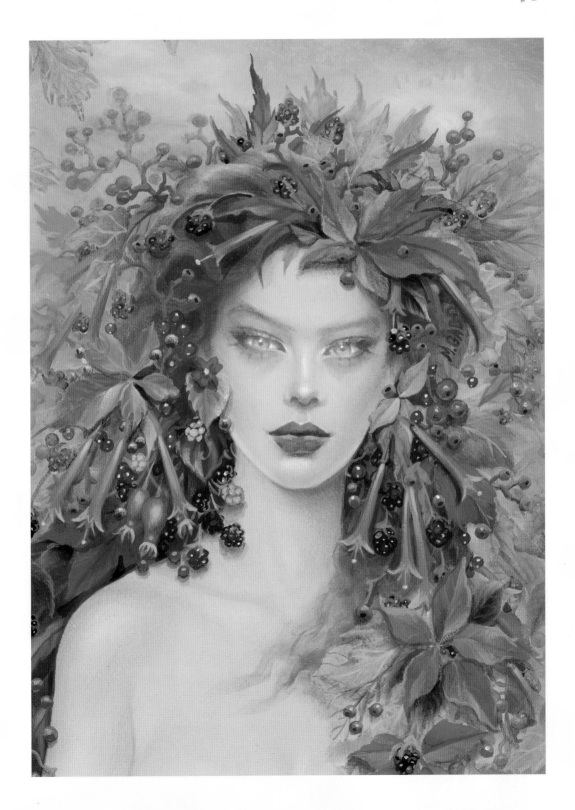

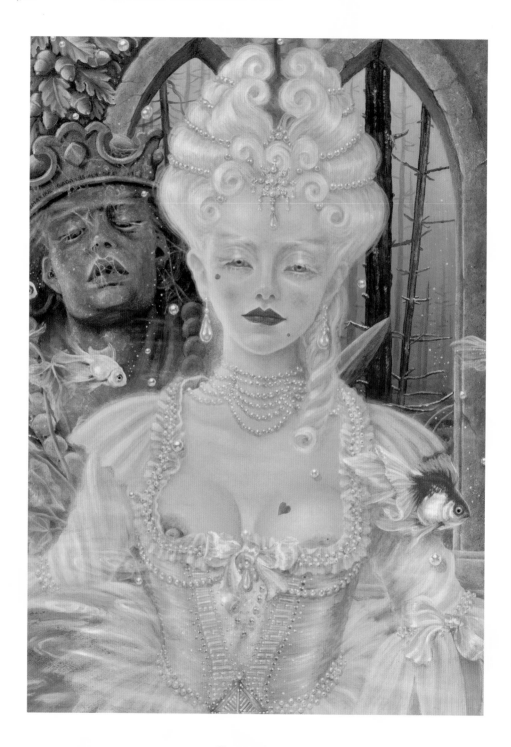

Pearlescence

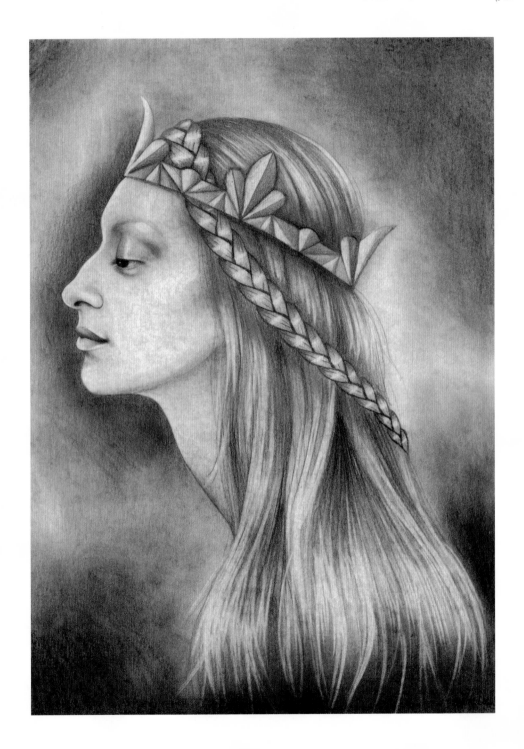

Princess

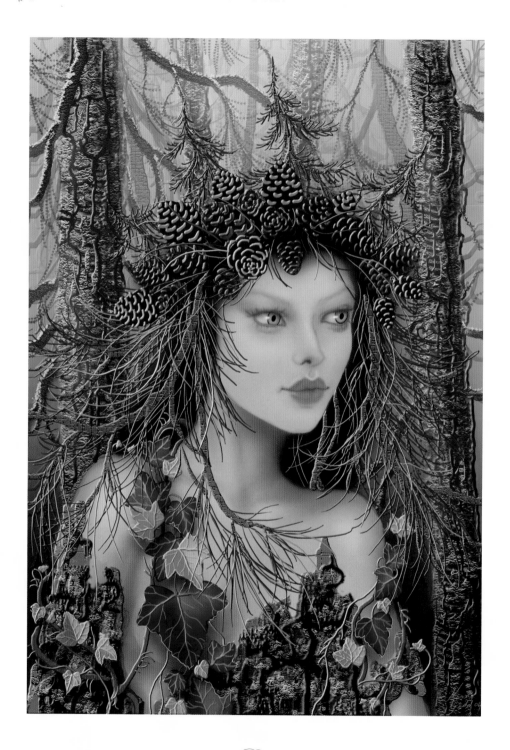

Pine

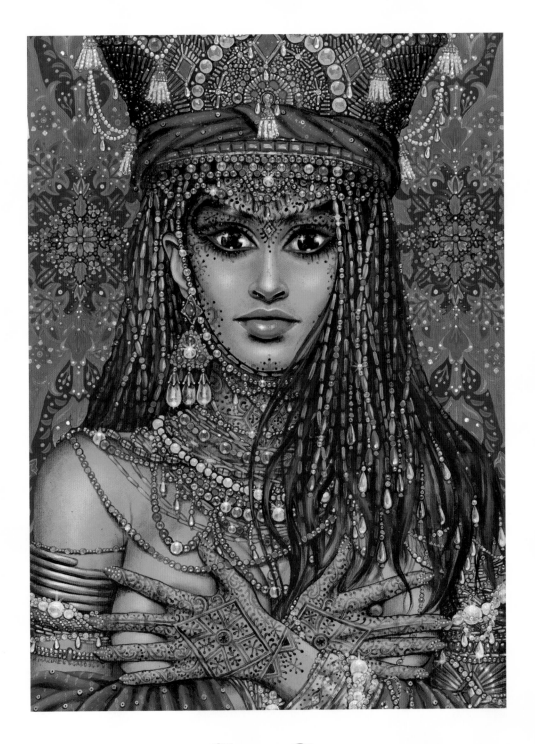

Brass and Rubies

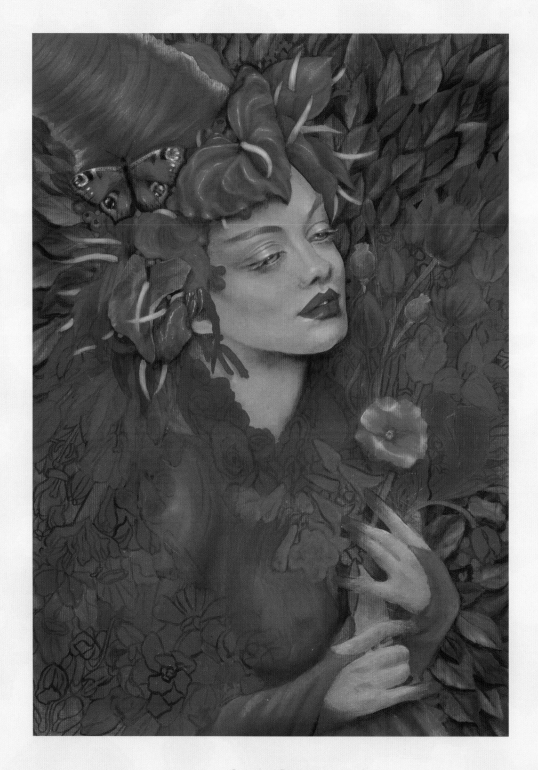

Love Potion

Dark Faeries

Her *lips were red,* her *looks were free,*
Her locks were yellow as gold:
Her skin was as white as leprosy,
The Night-mare LIFE-IN-DEATH *was she,*
Who thicks man's blood with cold.

– Samuel Taylor Coleridge,
"The Rime of the Ancient Mariner" (1797-8)

EVEN THE FAERIES go in fear of those among their number who owe allegiance to the darkness. Much more so should we mortals tread with caution if we sense that one of the dark faeries has turned an eye upon us. They are the denizens of treacherous marshes whose airs can choke us, of deep caverns whose very shadows encroach to threaten us, of the places where our every instinct calls out to us we should not go.

Is that the howl of the wind you hear in the depths of the starless night, or is it the scream of the banshee as she comes to claim your soul?

*"I love creating dark spirits most of all. I can express
my negative feelings through them without hurting
anyone. It is an eloquent form of revenge, a private joke
without harmful repercussions."*

Maxine Gadd

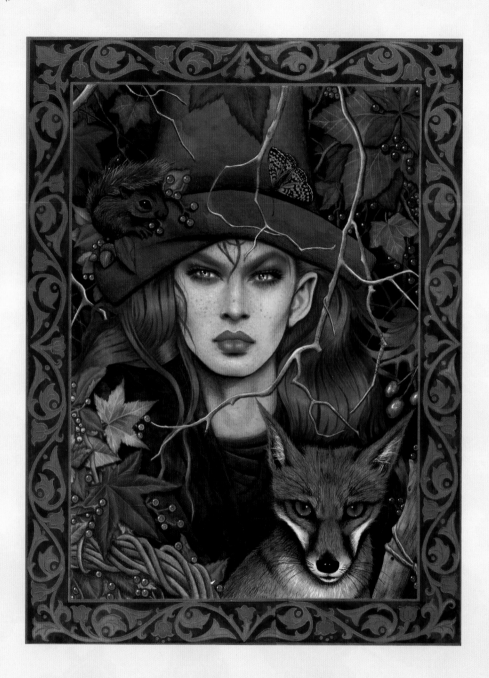

Amber Witch

RIGHT:

Spell

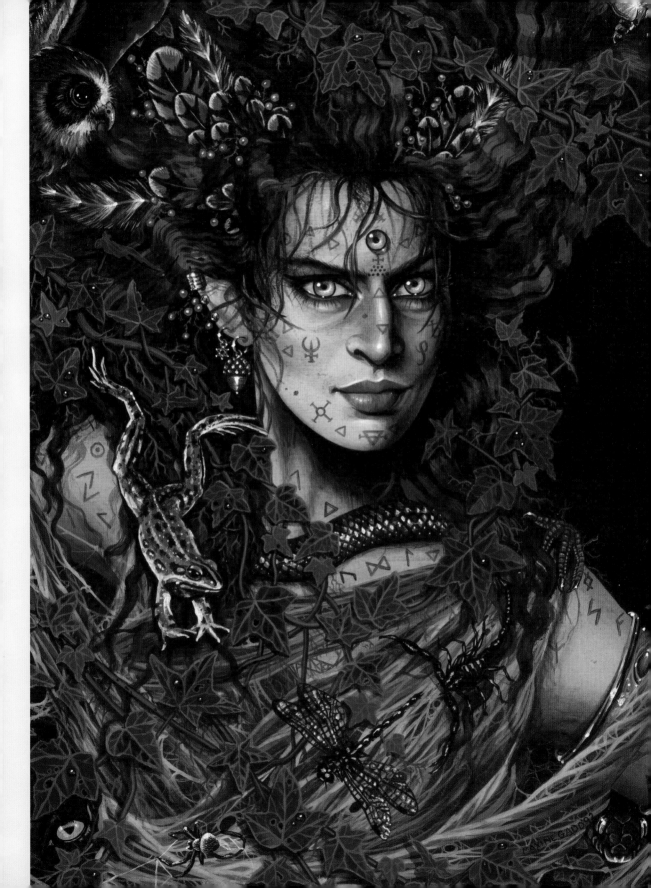

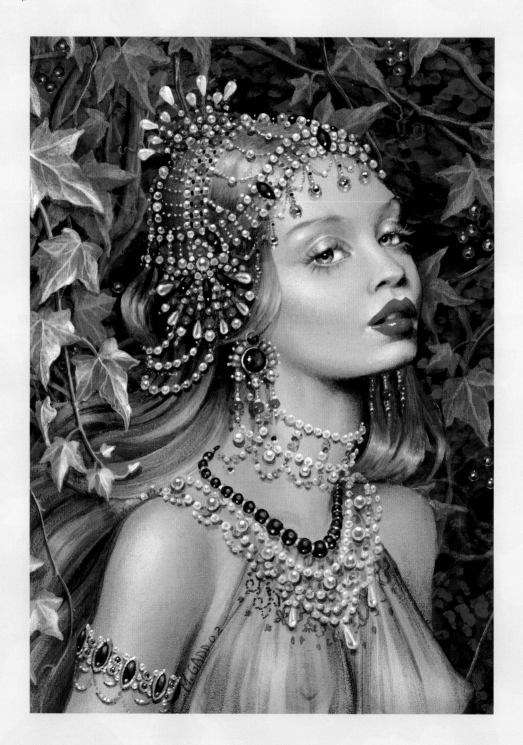

Melusine

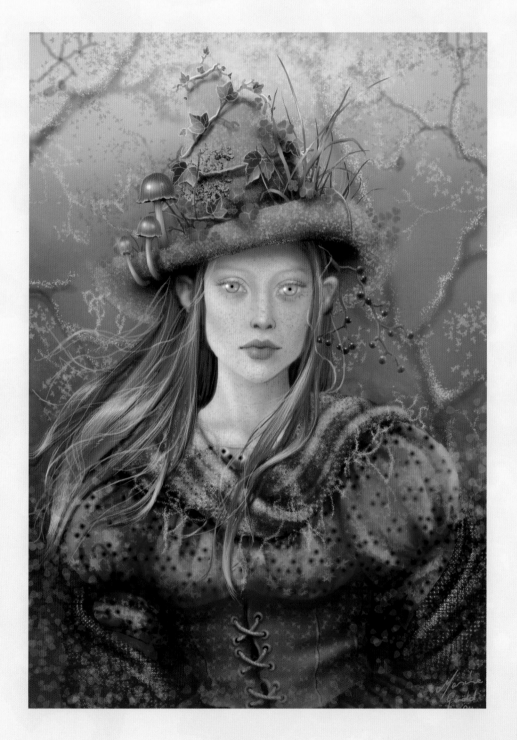

The Green Witch

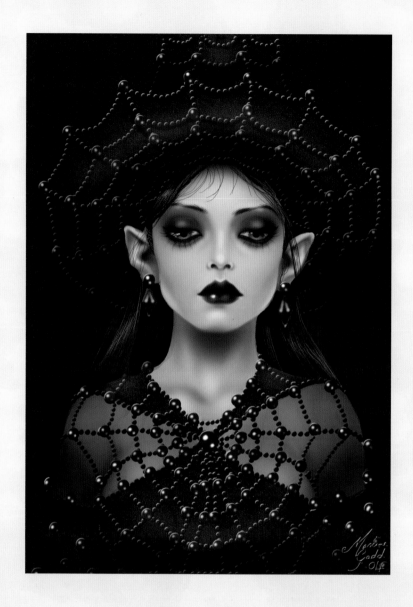

Widow's Weeds

RIGHT:
Vampire Bride

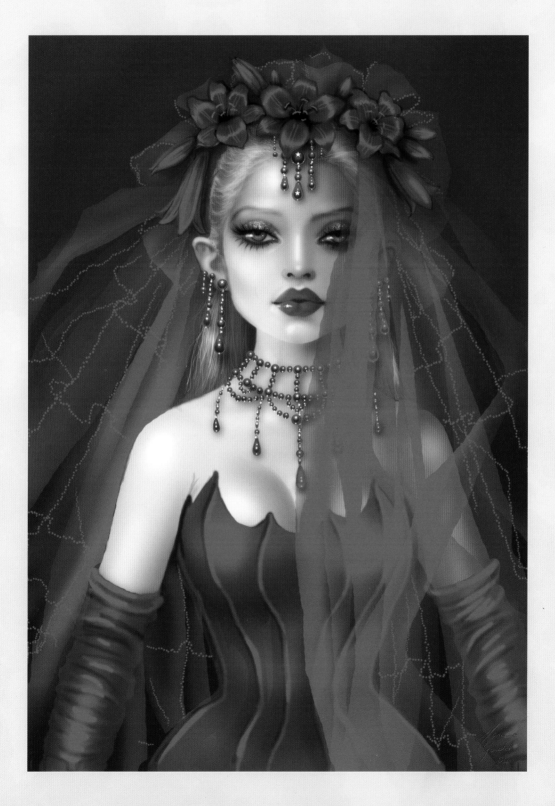

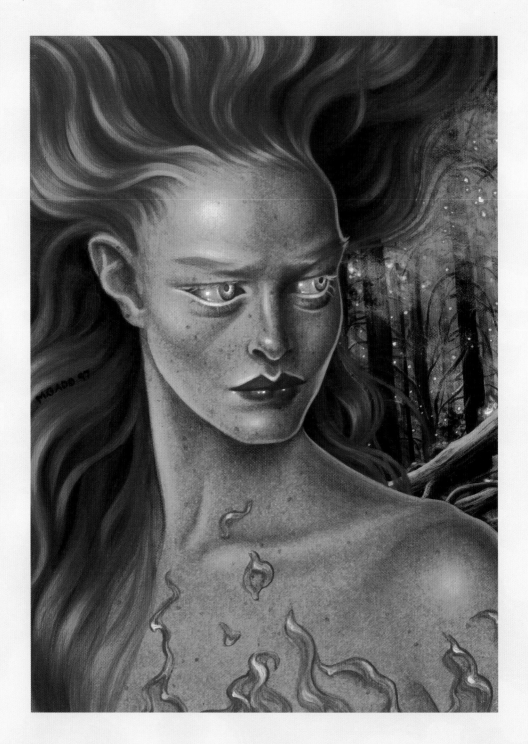

Burning

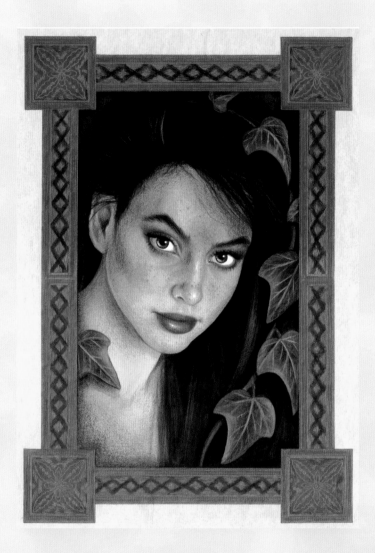

Belladonna

*"My idea of dark faeries is that they are strong individuals
who are unencumbered by the need to conform.
Their power lies in the fact that they don't need or want
to be liked."*

Maxine Gadd

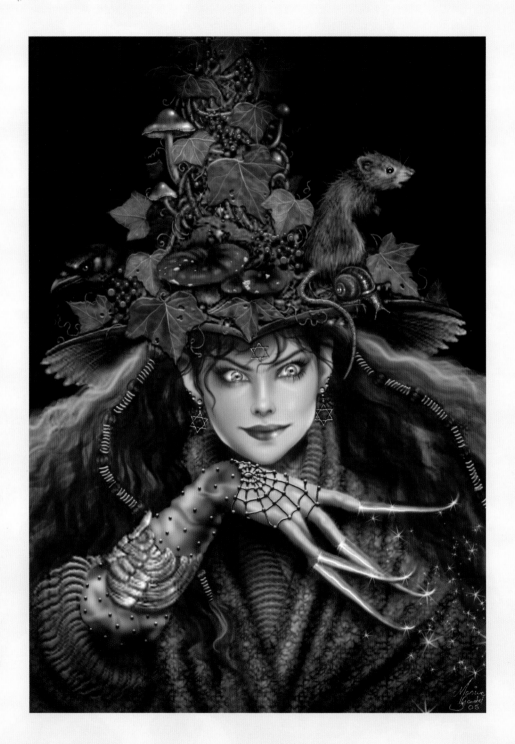

The Spell

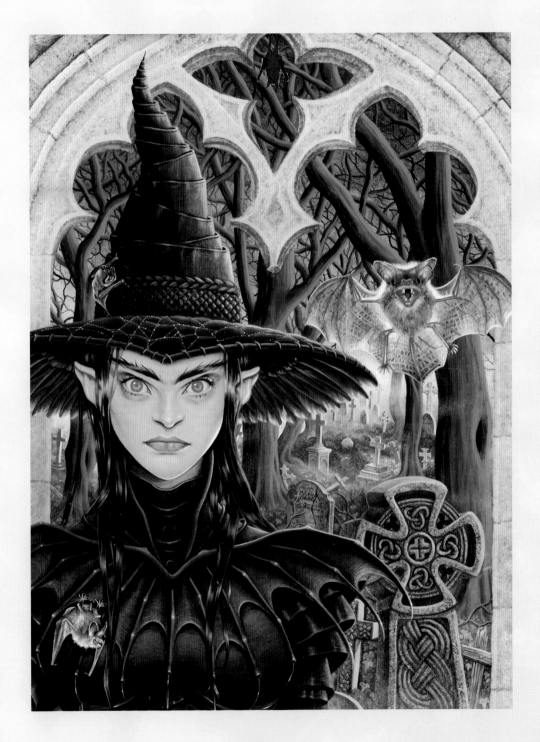

Hellebore

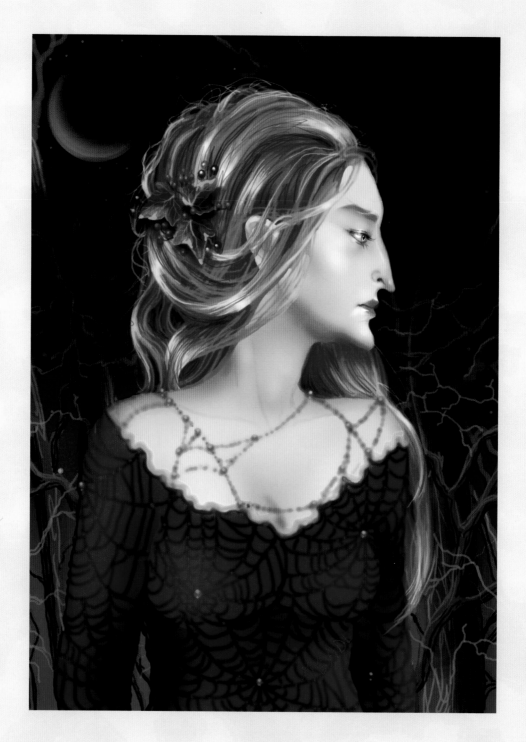

Isabelle

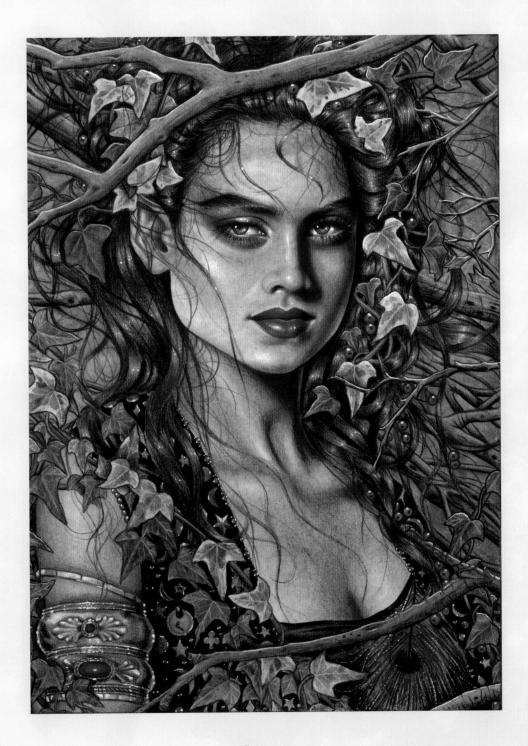

Bewitched

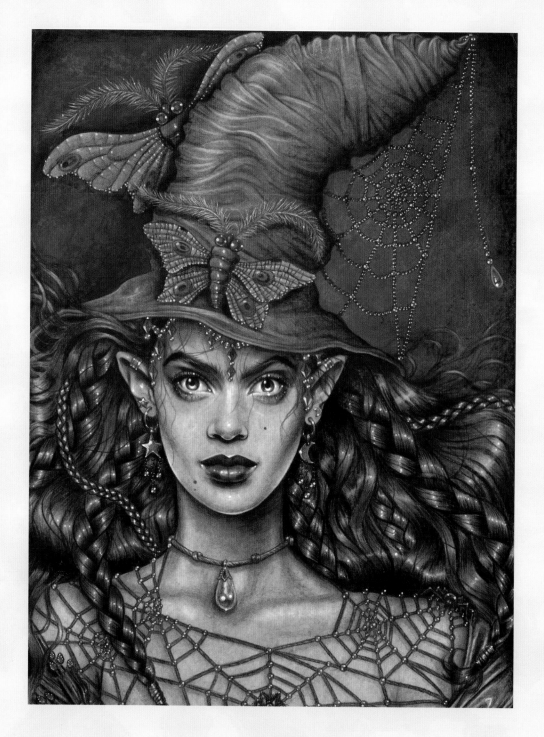

Amarylis Hopwood

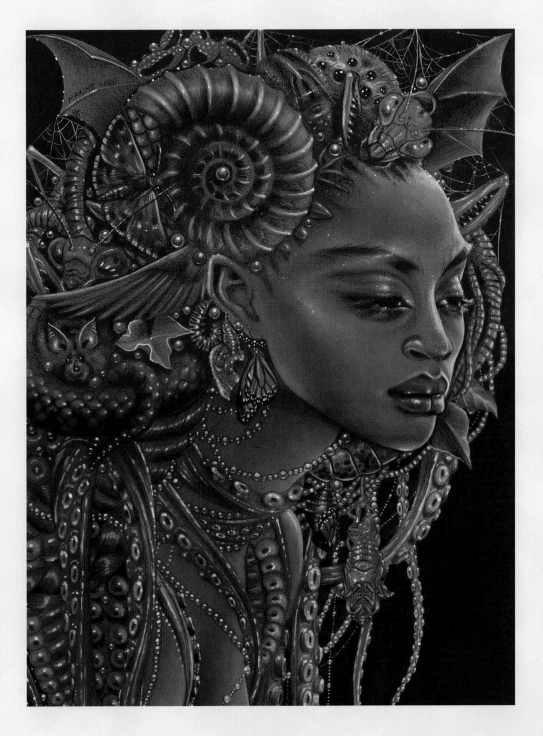

Dark Thoughts

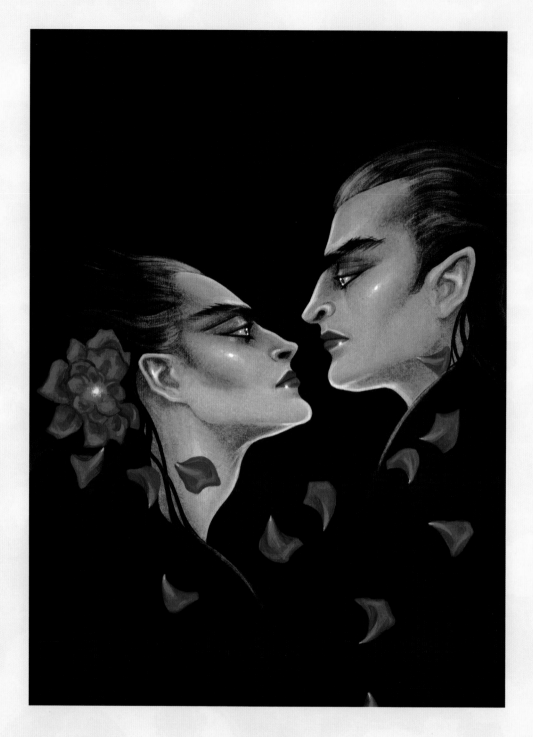

Vampire Lovers

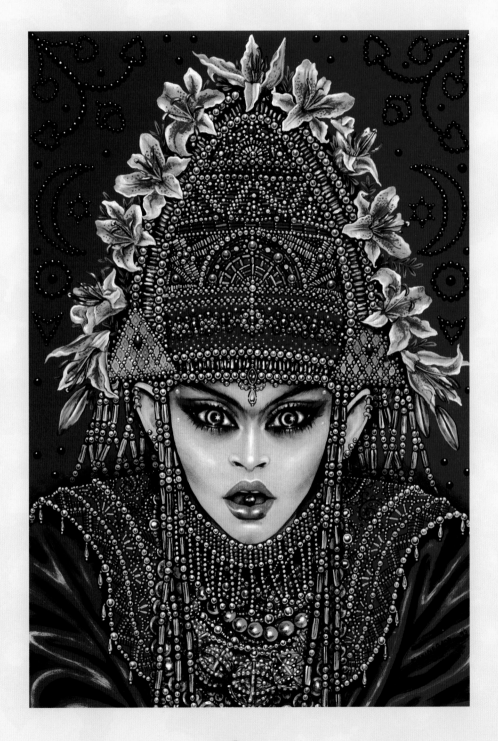

Poison

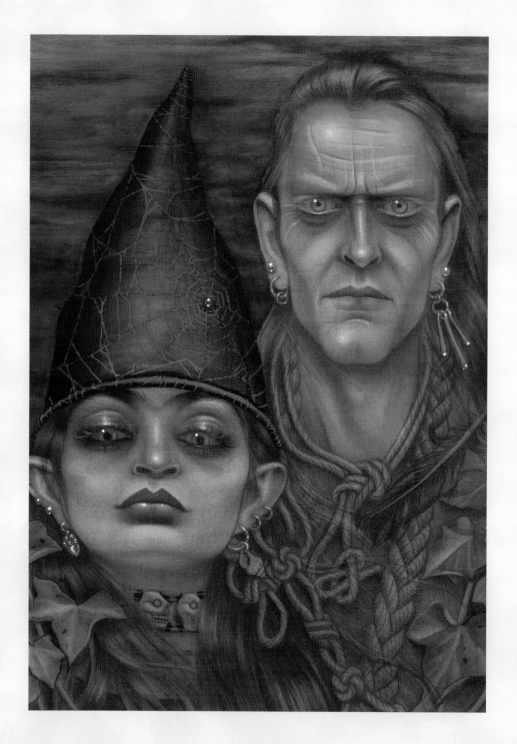

Wicca Knots

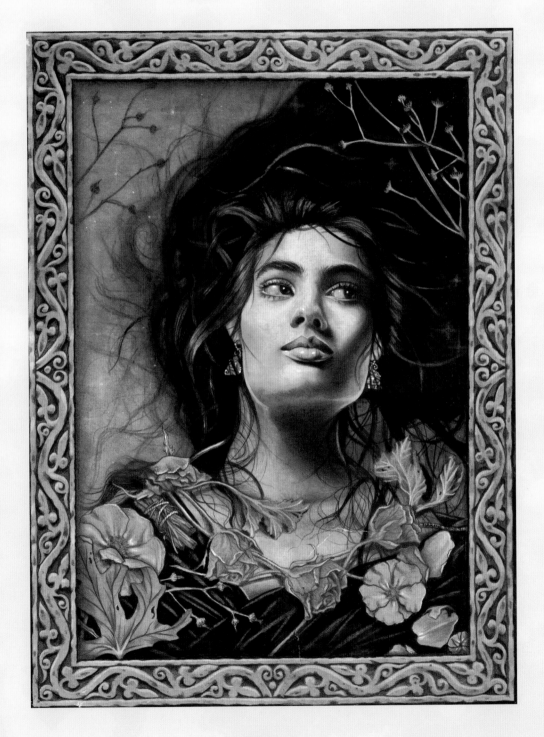

Ducking

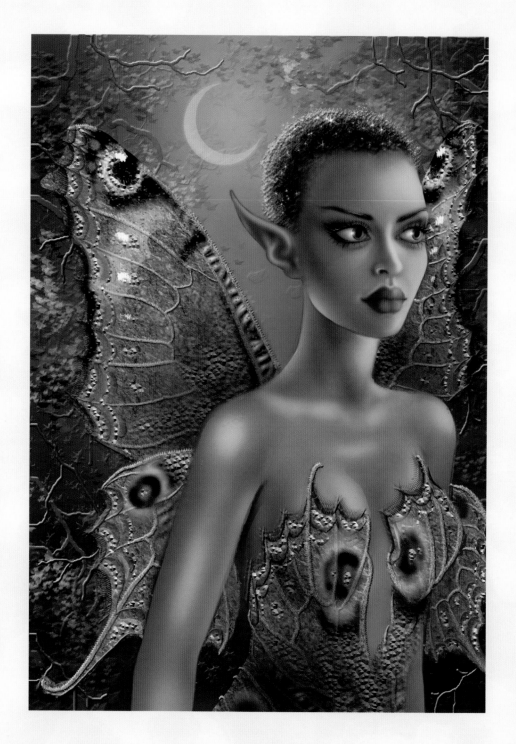

Gloaming

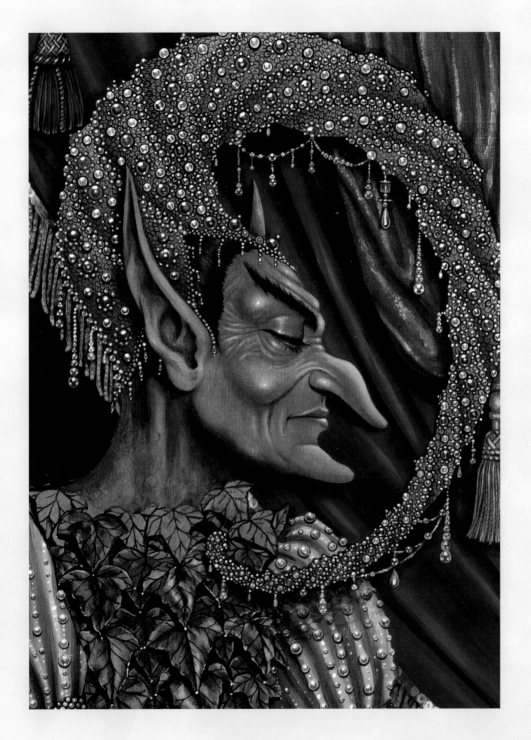

The Golden Goblin

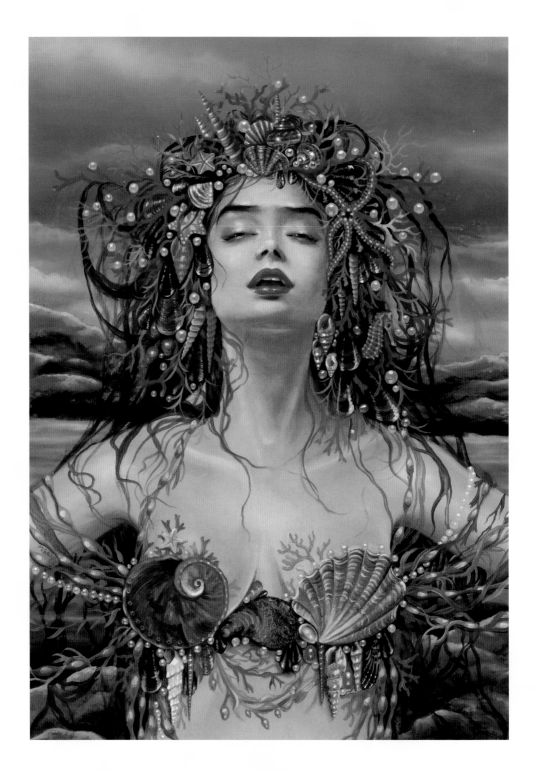

Sea Tangle

Mermaids

Sabrina faire
 Listen where thou art sitting
Under the glassie, coole, translucent wave,
 In twisted braids of lillies knitting

The loose traine of thy amber-dropping haire,
 Listen for deare honours sake
 Goddesse of the silver lake
 Listen and save.

–John Milton, "Sabrina Faire", from *Comus* (1634)

THE MULTITUDE of the beings of Faerie are of the land and air, but some are born of the water. Most known of these are the mermaids, whose exquisite beauty and alluring song have dragged many a willing suitor to his delightful demise. They are cousins to the water nymphs known as undines, and to the Lorelei who haunts the waters of the Rhine. Even the island-dwelling sirens who tempted the crew of Orpheus's great ship Argo are kin to the mermaids.

Woe betide the man who takes a mermaid as his faery bride! For she will promise to be his loyal lover only then to transport him to his doom.

The Golden Mermaid

RIGHT:
Ondine

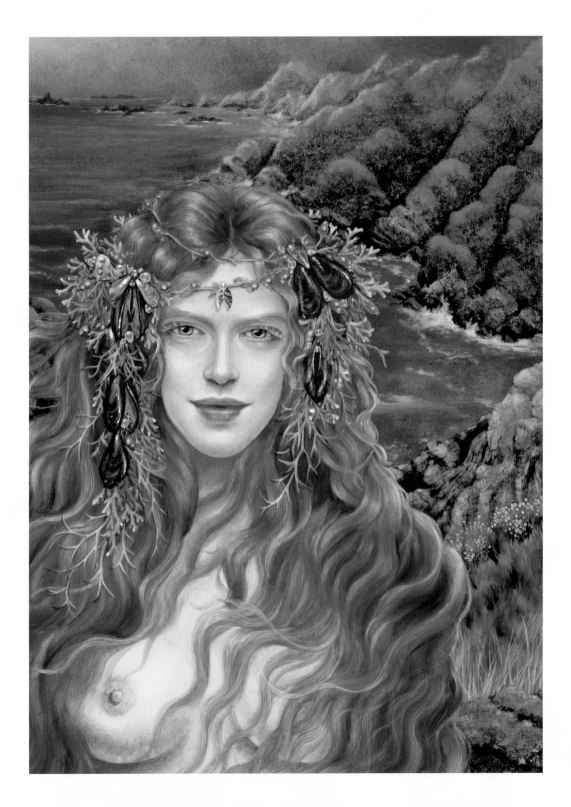

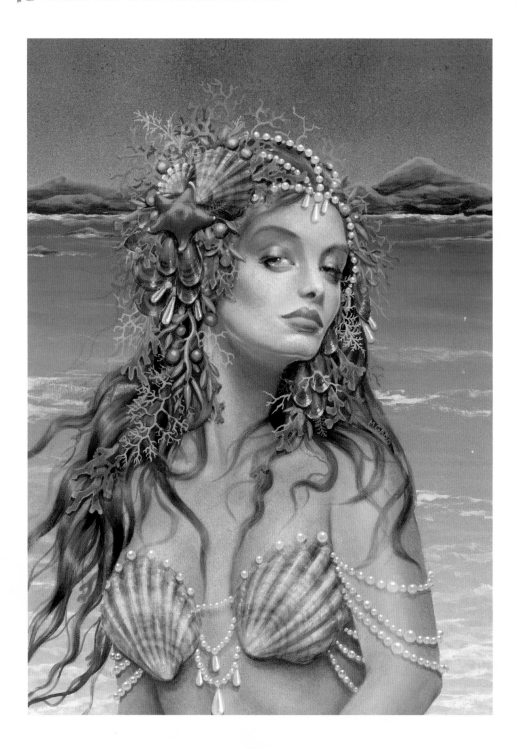

Diva

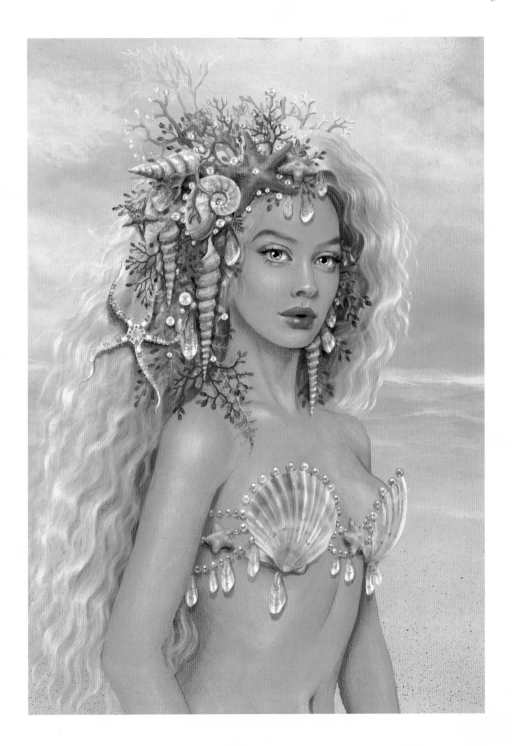

Coralina

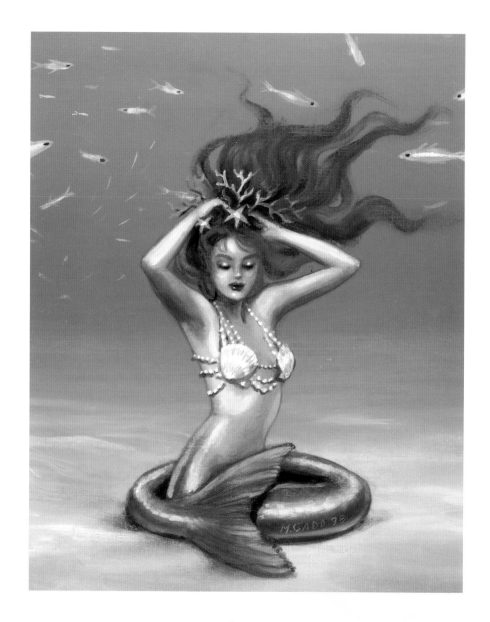

Lyria

RIGHT:

Sea Pearl

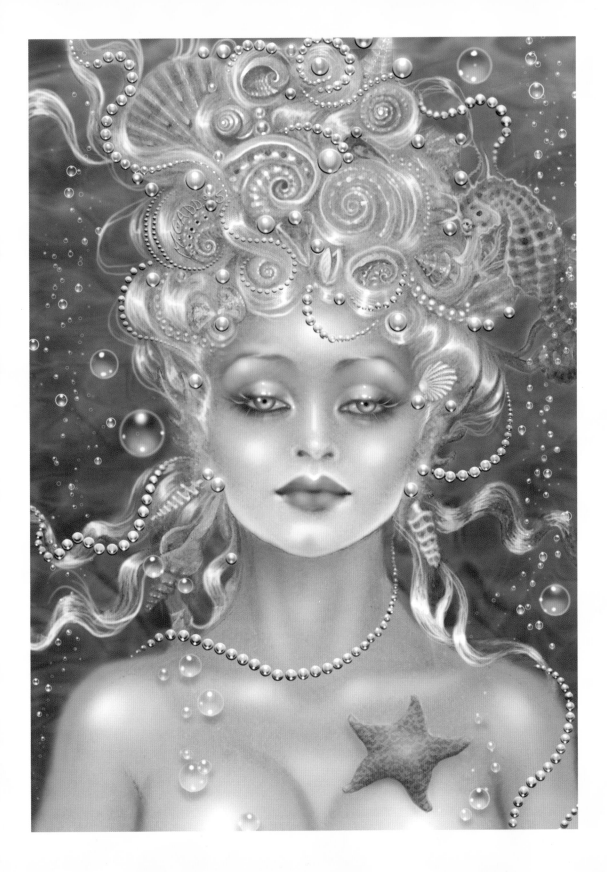

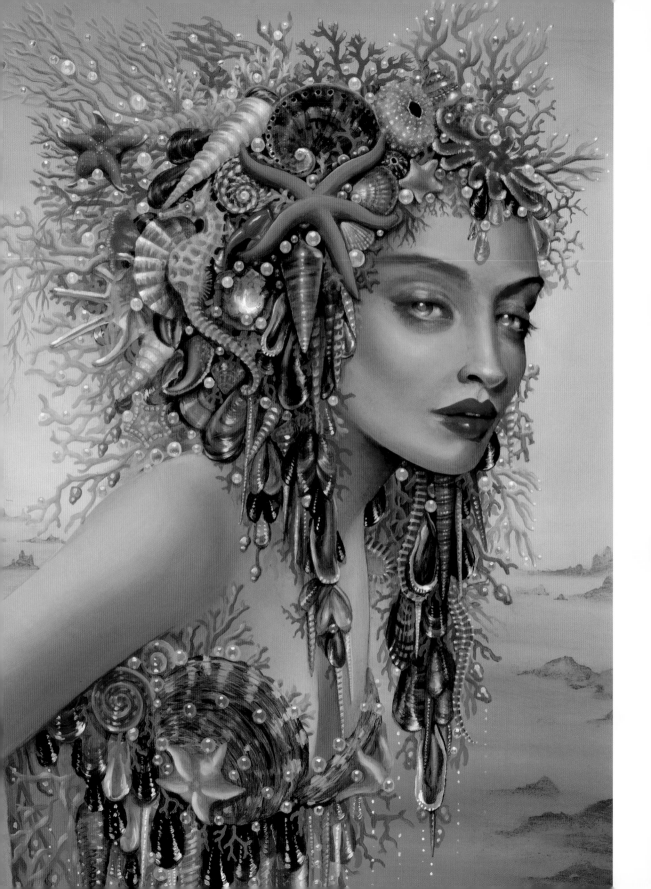

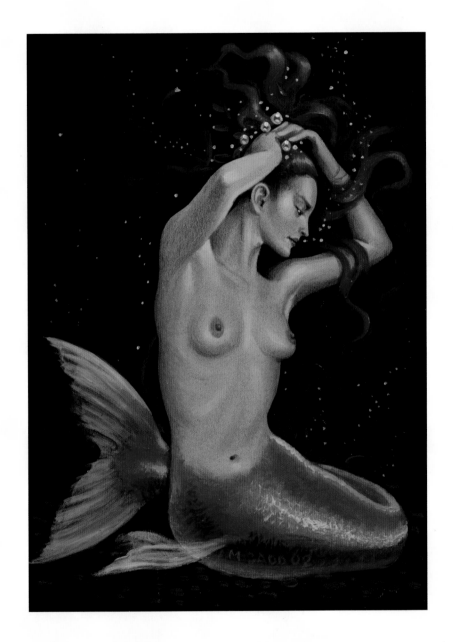

Reed Nymph

LEFT:
Sea Sprite

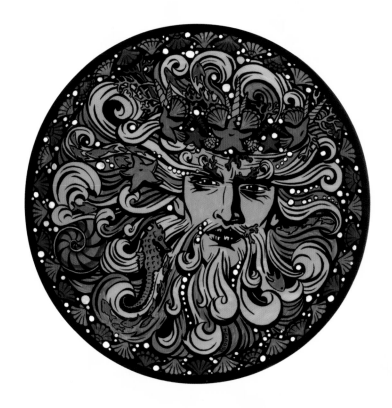

Neptune

"In nearly all the stories, human interaction with mermaids ends in tragedy. Just like the ocean, mermaids possess a cold beauty that is best observed from afar."

Maxine Gadd

RIGHT:

Fiskamancy

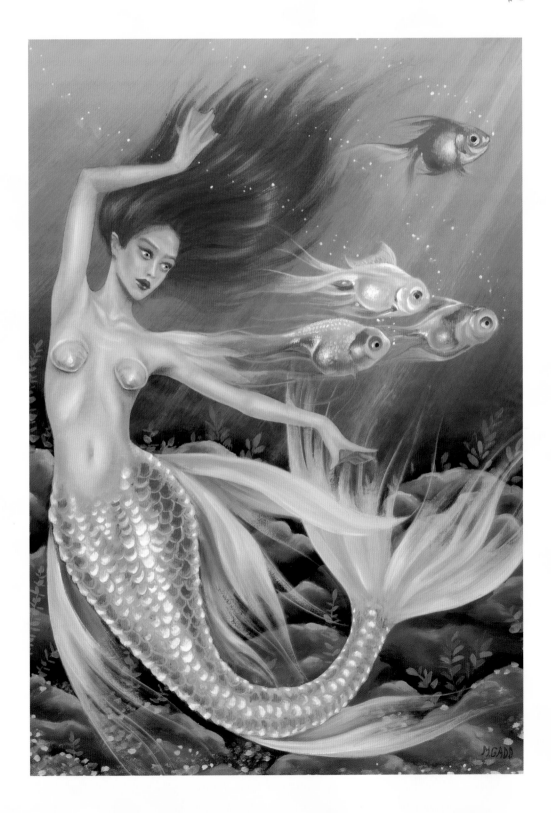

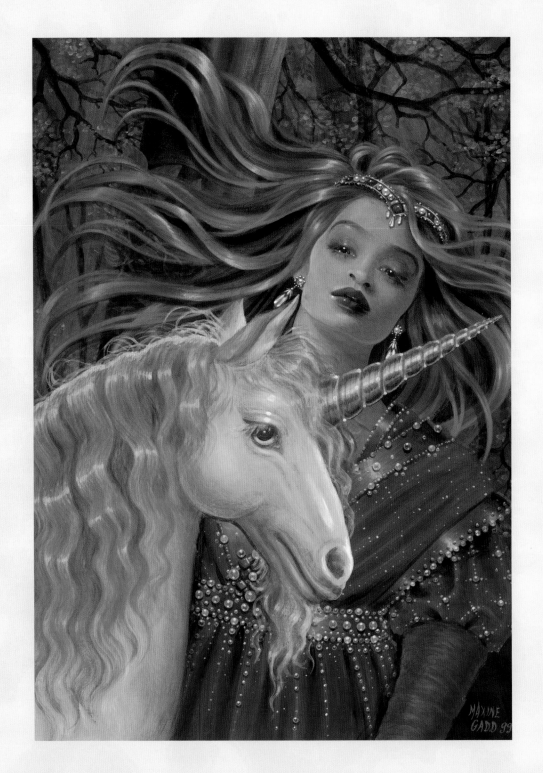

Nexus

In Faeryland

Fairies, arouse
Mix with your song
Harplet and pipe,
Thrilling and clear,
Swarm on the bows!
Chant in a throng!
Morning is ripe,
Waiting to hear.

– William Allingham, "A Forest in Fairyland",
written for Richard Doyle's *In Fairyland* (1870)

Countless are the denizens of Faerie, and countless also the guises they can take – some even shield themselves from mortal eyes entirely, so we can only guess at their forms. The dancing pixies and the ethereal elves, the quarrelsome leprechauns and the lightsome peris – all these, as well as the crosspatch goblins and the fearsome trolls, are but the visible aspect of Faerie.

Before we say our adieus to the kingdom of the elementals, let us take one last gaze around us and survey the riches the kingdom offers . . .

Up the airy mountain,
Down the rushy glen,
We daren't go a-hunting
For fear of little men
Wee folk, good folk,
Trooping all together;
Green jacket, red cap,
And white owl's feather!

–William Allingham, "The Fairies" (1855)

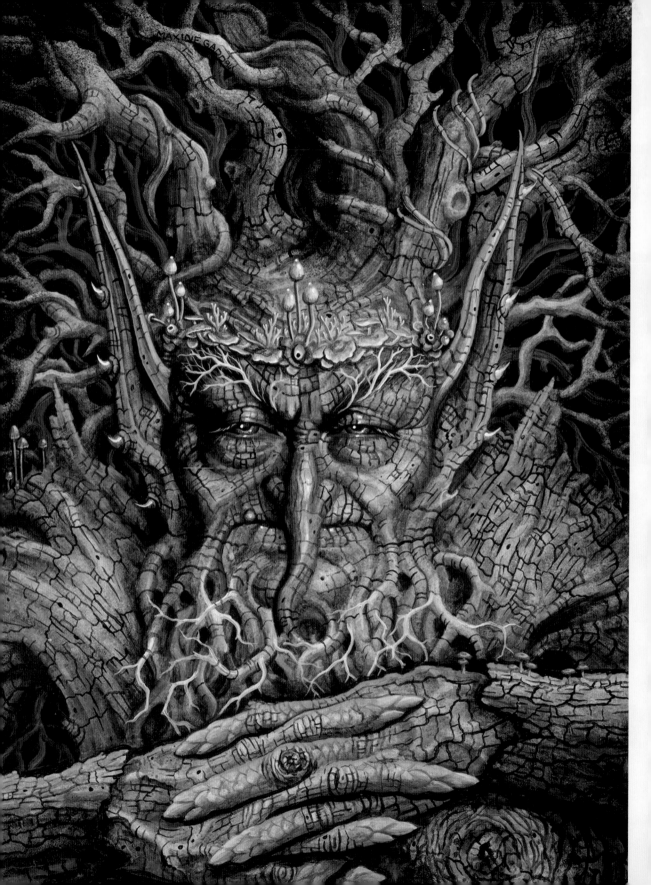

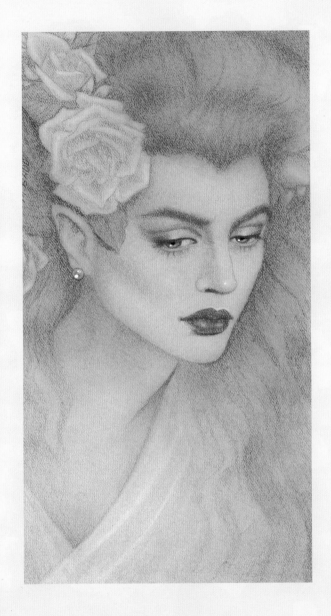

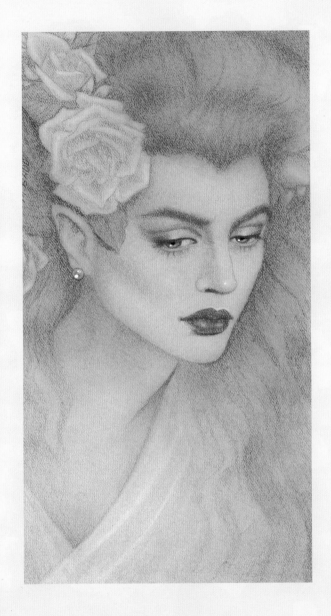

"I think people love faeries because they see faeries as free spirits who spend most of their time expressing beauty. Faeries move with a graceful ease, are forever young, and never hold back their emotions."

Maxine Gadd

Tea Rose

LEFT:

Thimius

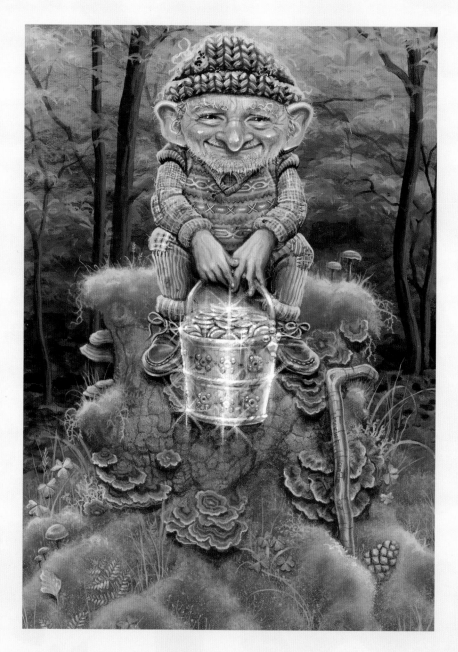

Irish Leprechaun

RIGHT:
Mystic Stitch

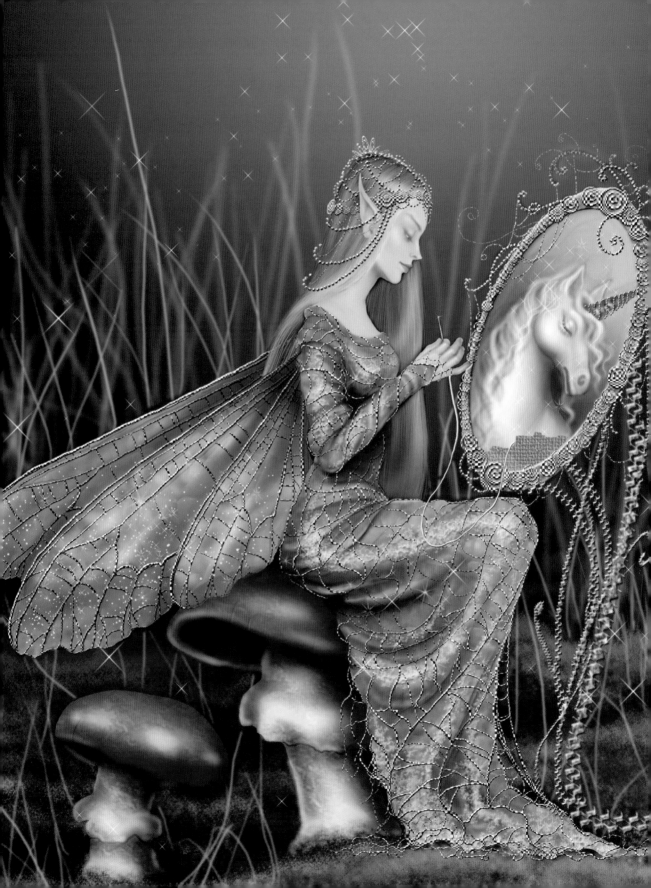

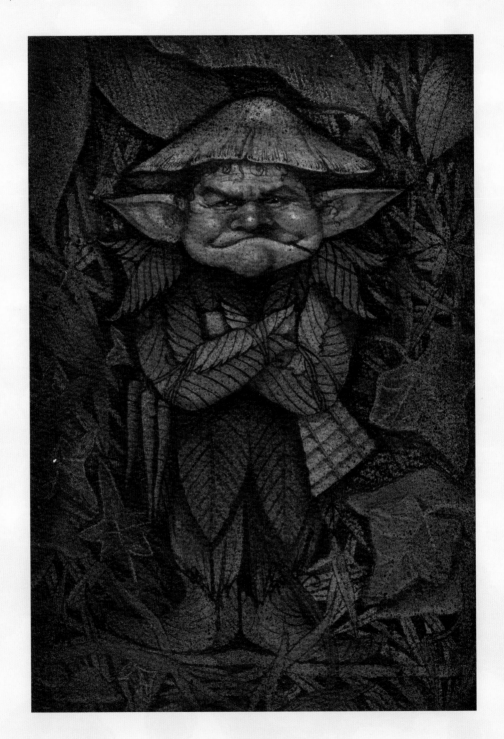

Snifty

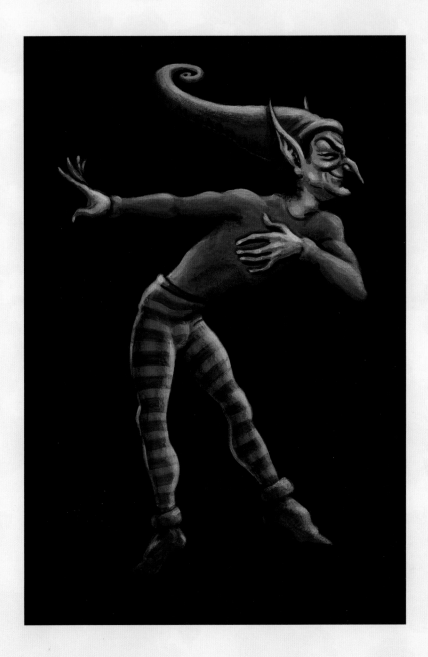

Hob-Goblin

OVERLEAF:
Rose Wood

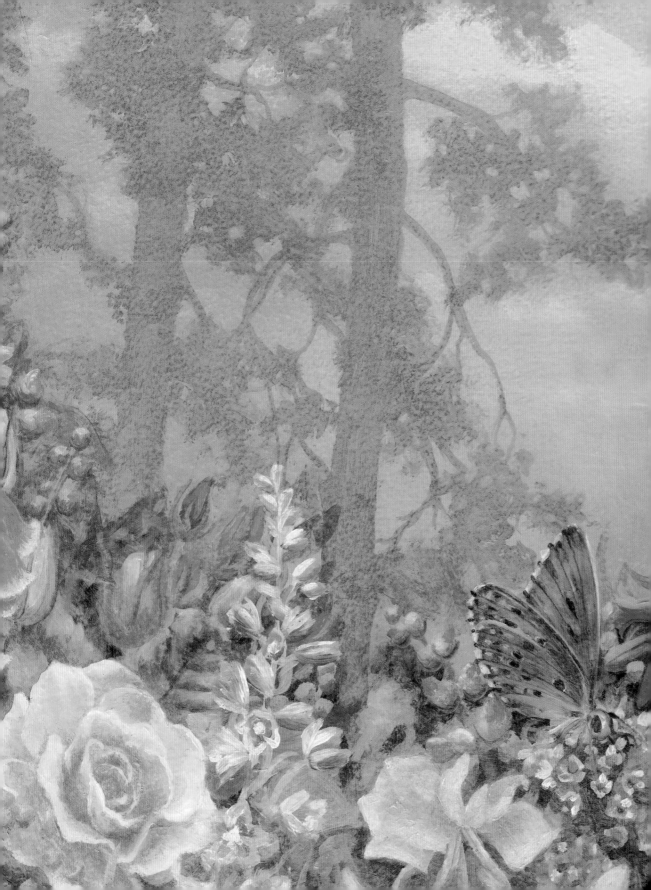

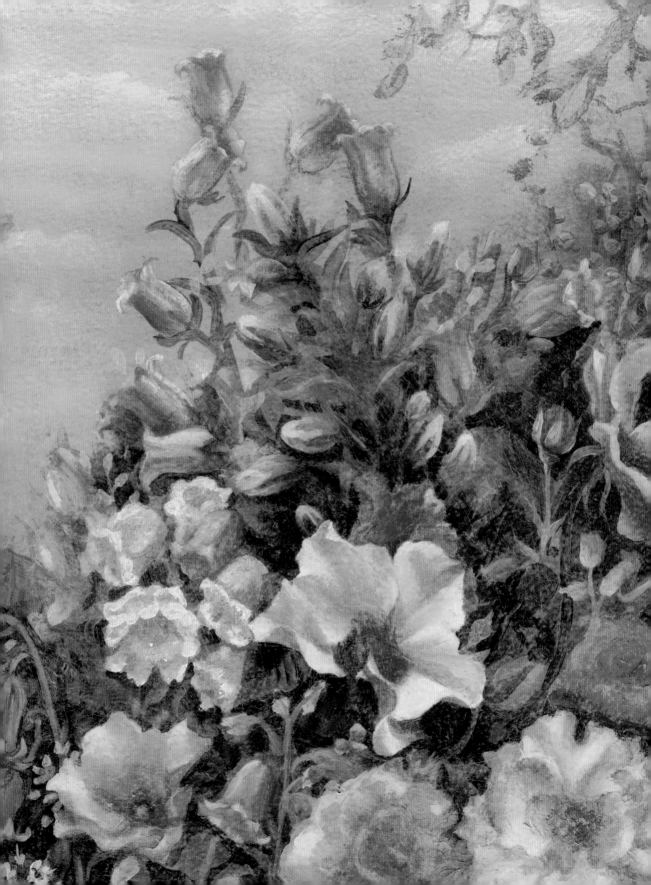

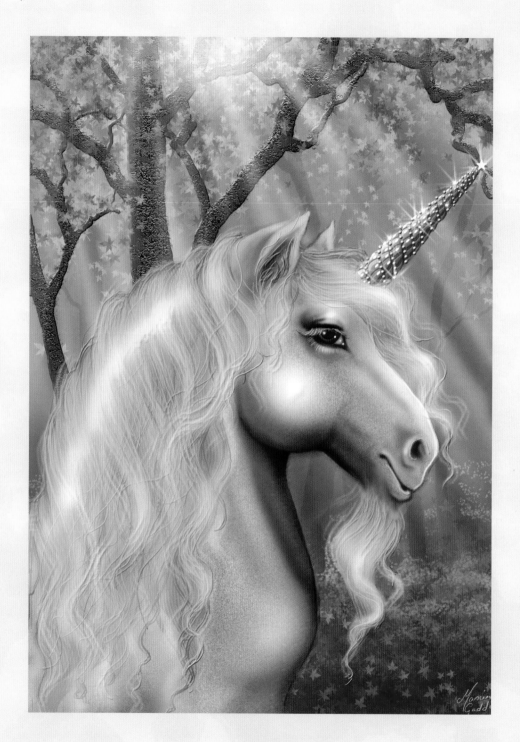

Pearl

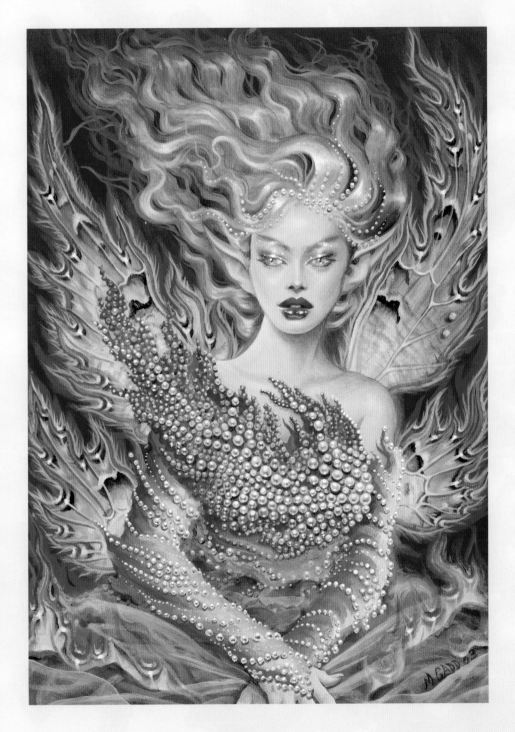

Fire Sprite

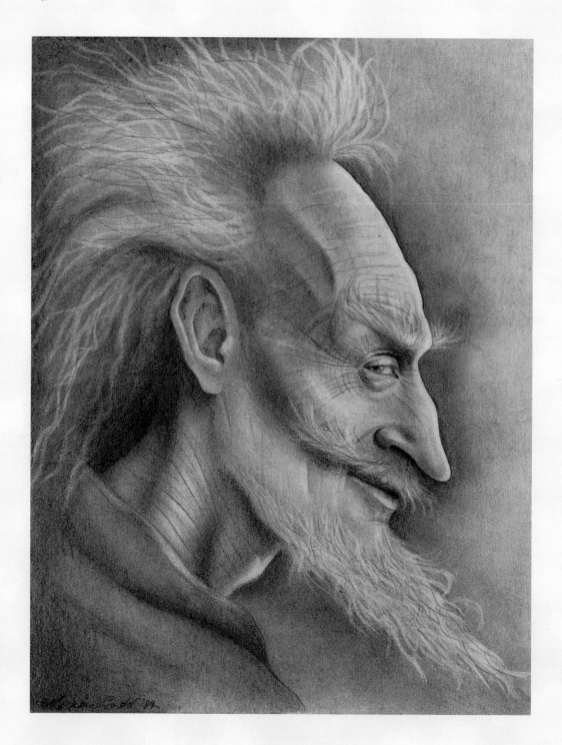

Maengel

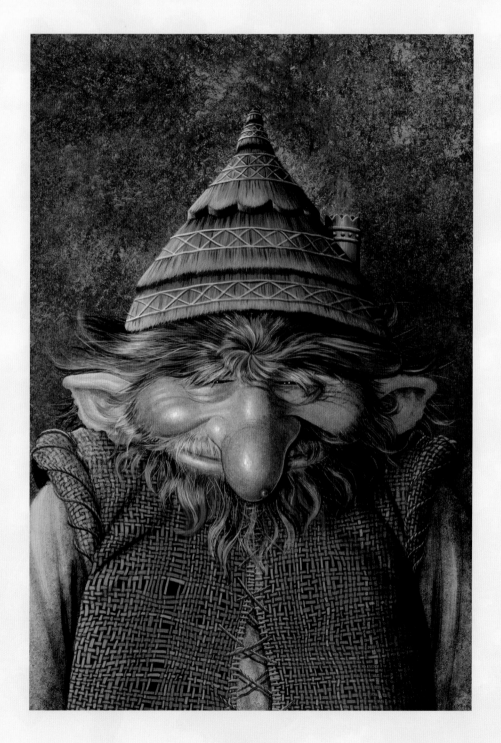

Troll

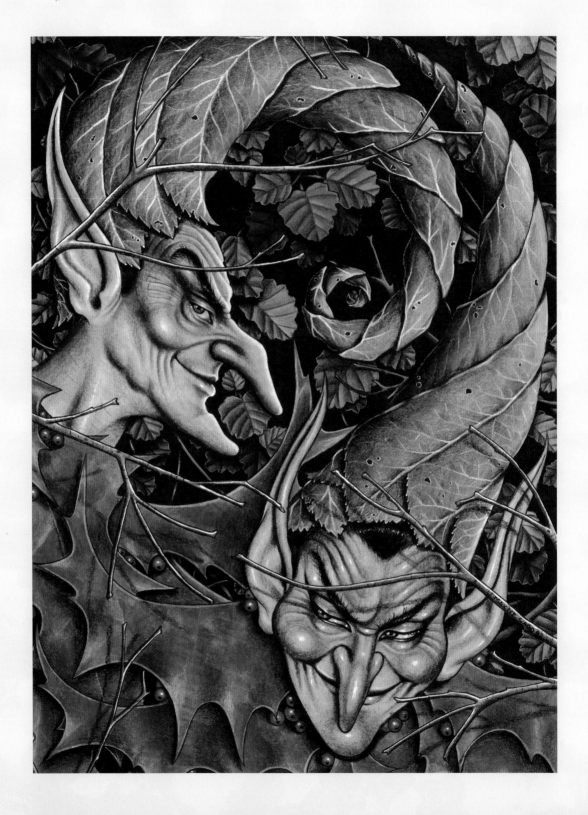

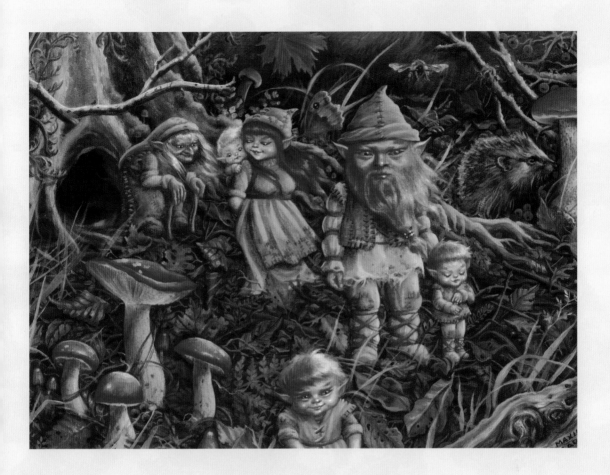

Green Pixies

"As we get older and become ever more caught up in our everyday lives, we need the strangeness of fantasy stories and art to refresh and surprise us with the constant newness of life."

Maxine Gadd

LEFT:
Slith and Snurch

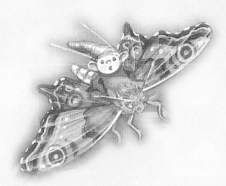

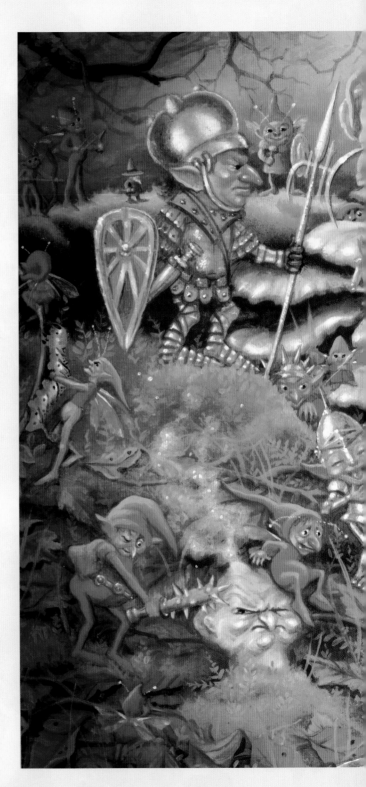

Pixie Gang

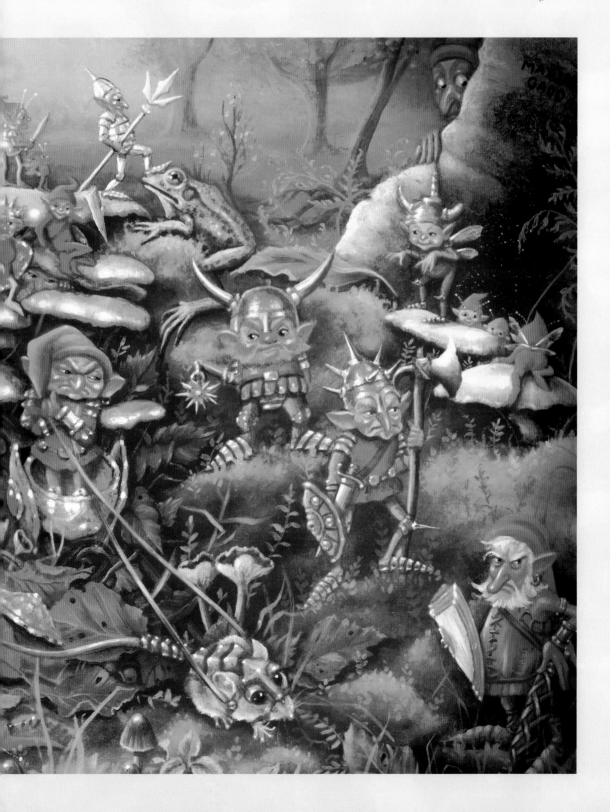

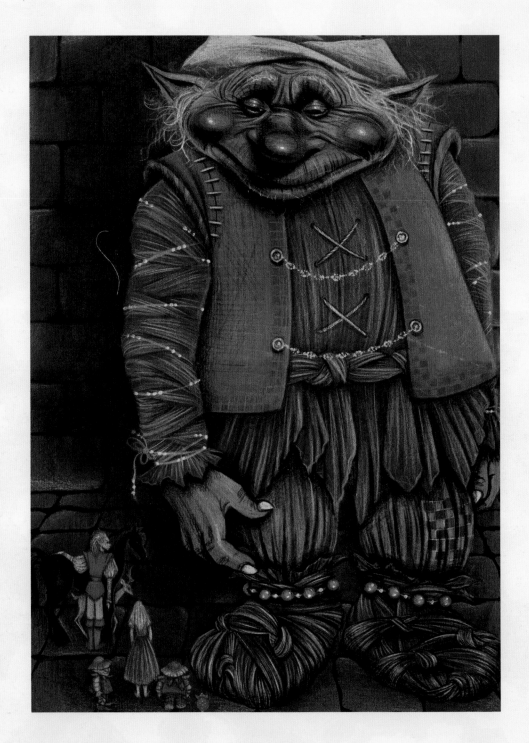

The Troll's Dungeon

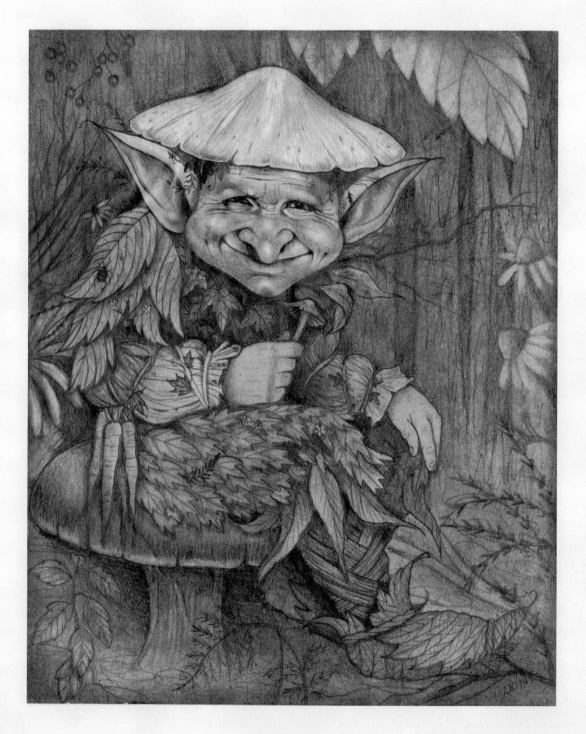

Griesle-Fleaf

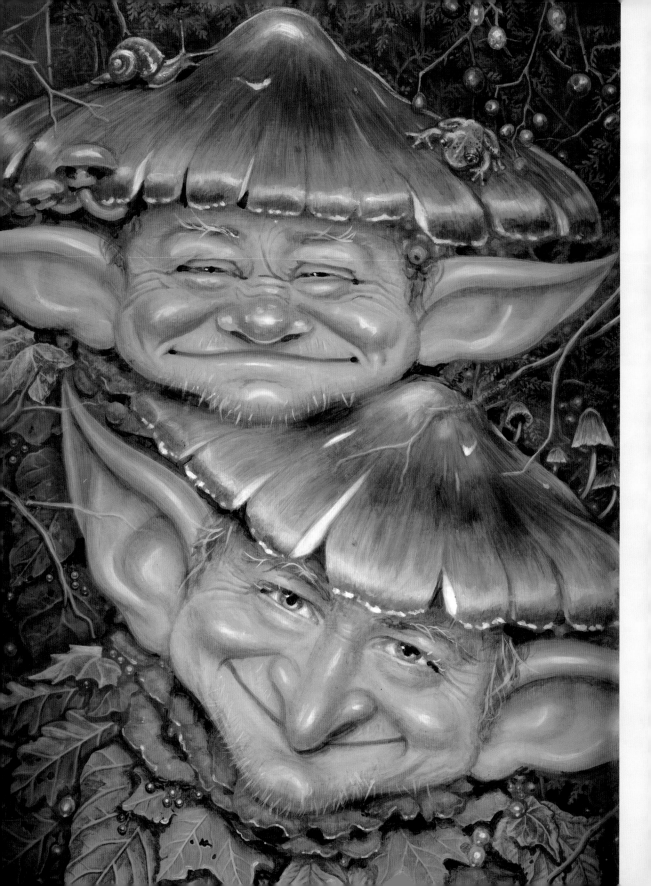

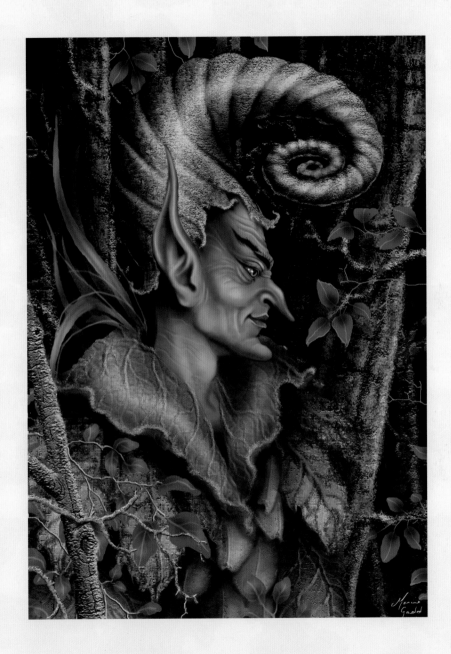

King of the Goblins

LEFT:

Mushroom Pixies

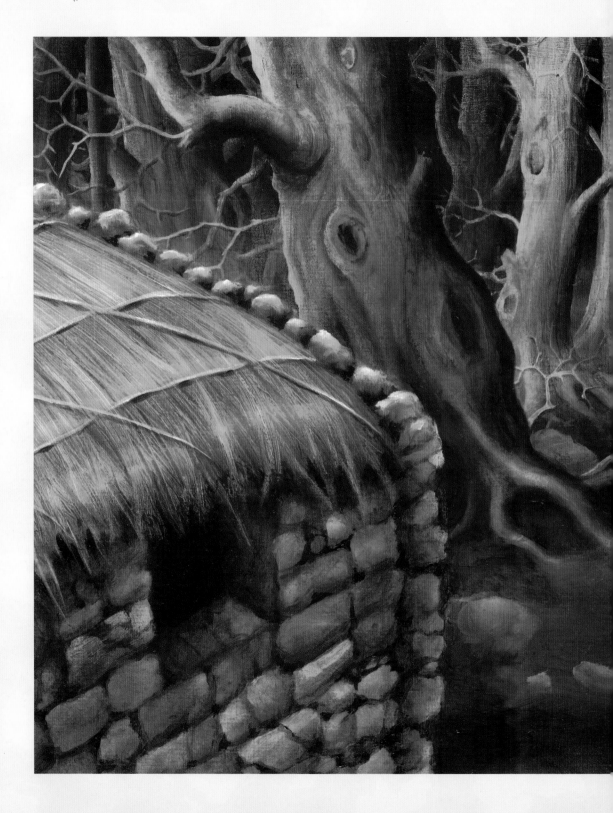

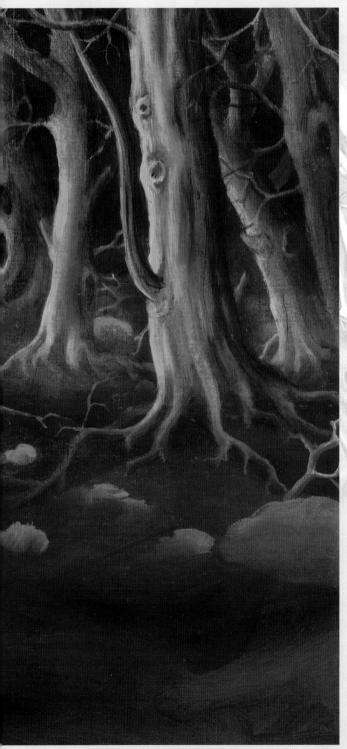

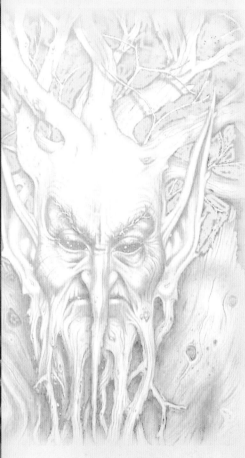

Troll Cottage

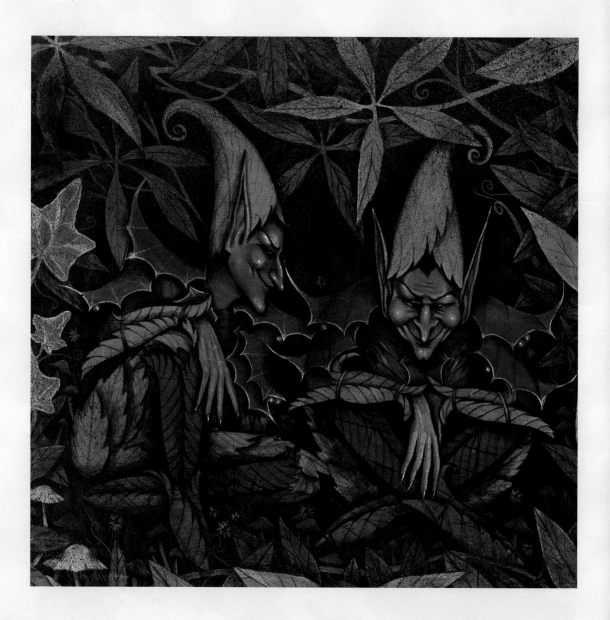

Scheming Goblins

RIGHT:

Auspice

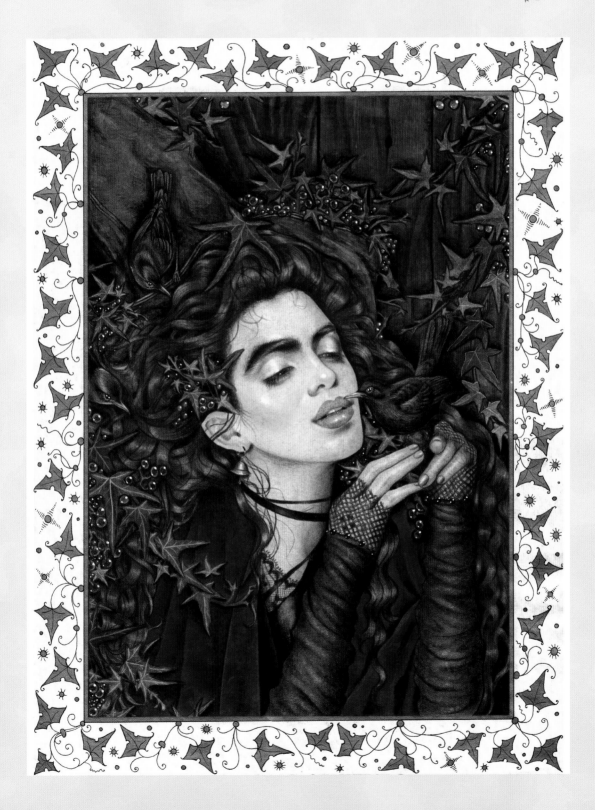

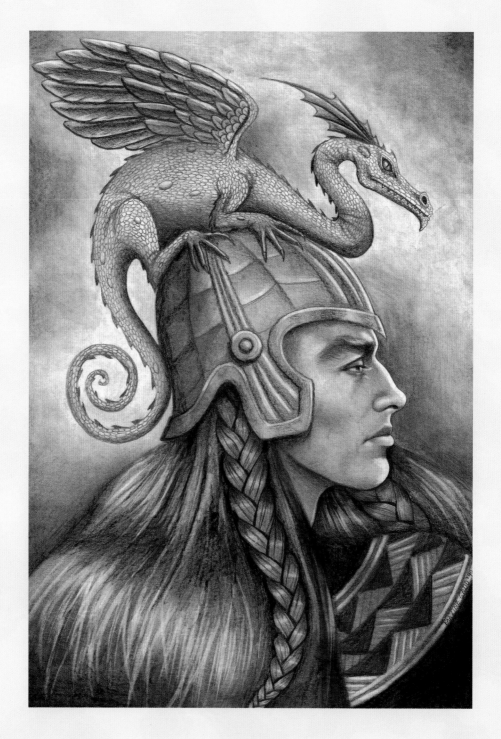

Faery Warrior

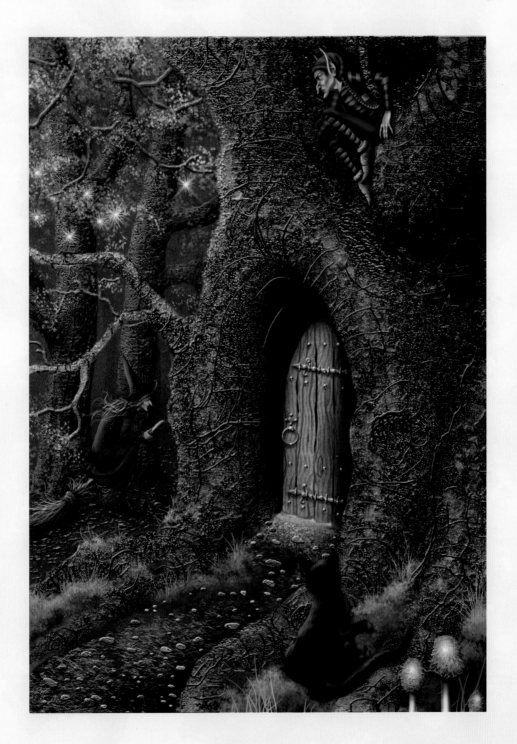

Wicca Tree

Farewell to Faerie

And there she lulled me asleep,
* And there I dream'd – Ah! woe betide!*
The latest dream I ever dream'd
* On the cold hill's side.*

I saw pale kings and princes too,
* Pale warriors, death-pale were they all;*
They cried – "La Belle Dame sans Merci
* Hath thee in thrall!"*

I saw their starved lips in the gloam,
* With horrid warning gapèd wide,*
And I awoke and found me here,
* On the cold hill's side.*

And this is why I sojourn here,
* Alone and palely loitering,*
Though the sedge is withered from the lake,
* And no birds sing.*

– John Keats, "La Belle Dame Sans Merci" (1819)

THE JOURNEY into the land of Faerie has been not without its risks, for the denizens of that kingdom do not think as mortals do: they have emotions and motivations that are different from ours, and often these can manifest themselves as whimsical cruelty. And yet, as with love, surely the ecstasies of the adventure more than outweigh the hazards. If we lose

The Woodwose

our heart to a faery, as Keats's "alone and palely loitering" knight lost his, then we are losing it to magic and enrapturement.

What is always left unstated – and what restrains the cruellest of faeries from tormenting us too grievously – is that Faeryland and the faeries themselves depend upon we mortals for their continued existence. Without the continued fascination for faeries and Faeryland in human minds all over the world, the Little People would fade and vanish like early-morning mists in the rays of the dawning sun. Our belief in them – and perhaps sometimes, yes, even our love for them – is the very air that they breathe.

For, in a sense, Faeryland is a hall of enchanted mirrors. In those mirrors we see beings who seem magically strange to us – beings of mesmeric beauty who may also be terrifyingly sinister, but who are always distinguished by the way in which they are so remote in kind from us. And yet, if we move our arm or turn our head, we discover that these most unhuman of creatures are really . . . us.

"If you believe," he shouted to them, "clap your hands; don't let Tink die."

–J.M. Barrie,
Peter and Wendy (1911)

The Seer

About the Paintings

Numbers in **bold** refer to pages on which captions appear.

Dumple-Pud

Maxine Gadd

Artist's Acknowledgements

Firstly, a big thankyou to my husband and best friend,
Will, for supporting, inspiring and protecting me these
many years, so that I could develop the art contained
within these pages. Thanks are also due to my brother
Steve, to his wife Michelle, and to Amy and Ben, who were
and still are a joyful distraction from all the hard work!
I thank, too, my mother, who always believed me to be
an artist, right from the moment I held my first crayon
and started to scribble. Last, but never least, thanks are
due to the extremely talented artist Audre Vysniauskas
(audre), whose kindness and sheer effort in putting
me forward for publishing will never be forgotten;
to Cameron Brown, for believing in me; and to
Paul Barnett and Malcolm Couch for their creative
brilliance in bringing this book together.

Maxine Gadd